THE

ULTIMATE
GUIDE TO
IPHONE
PHOTOGRAPHY

Learn How to Take Professional Shots
and Selfies the Easy Way

THE

ULTIMATE
GUIDE TO
IPHONE
PHOTOGRAPHY

YASSEEN AND MOAZ TASABEHJI
Creators of CameraBro

PAGE STREET
PUBLISHING CO.

PAGE STREET
PUBLISHING CO.

First published in 2022 by
Page Street Publishing Co.
27 Congress Street, Suite 1511
Salem, MA 01970
www.pagestreetpublishing.com

Distributed by Macmillan, sales in Canada by The Canadian Manda Group.

26 25 24 23 22 1 2 3 4 5

ISBN-13: 978-1-64567-675-1
ISBN-10: 1-64567-675-7

Library of Congress Control Number: 2022939555

Cover and book design by Meg Baskis for Page Street Publishing Co.
Photography by Yasseen and Moaz Tasabehji

Printed and bound in the United States of America

 # DEDICATION

To our beautiful parents, Manal and Musallam, who put a roof over our heads and gave us the luxury of pursuing our dream even when it didn't make sense to them. Thank you for always being proud of us regardless of our achievements. You gave us the space to experiment and the support we needed to go higher.

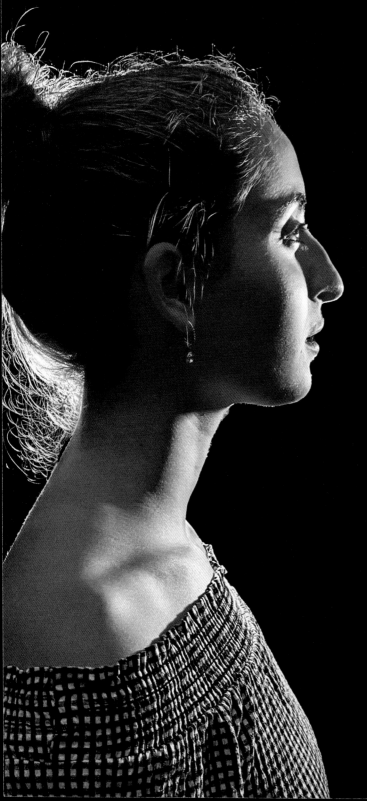

CONTENTS

MEET YOUR CAMERA BRO(S)

We're Yasseen and Moaz. Born in Syria and currently living in Toronto, Canada, we're full-time photographers, and we're lucky to be running CameraBro, one of the fastest-growing online photography education platforms.

Our story began in Damascus, Syria, where being artistic didn't have much value. Pursuing science was the way to go! We both did well in school, but we never ever considered ourselves creative. No music, no dance, no arts and crafts. Luckily, we had an old camera in the house that we both liked to play around with. We would take pictures of each other, pretty trees, crazy cats on our street, you name it.

After high school, we moved to Canada and started college. We liked photography, but we ended up pursuing undergraduate degrees in completely unrelated fields (biology for Yasseen and mathematics for Moaz)—this was a typical story of finding your passion in the last place you expect!

FUN FACT: Most people think we're twins, but we're actually one year and four months apart. Can you guess who's older?

Our interest in photography grew after college, and we started a wedding photography business in Toronto. It was a magical time! We got to capture beautiful memories on people's happiest days—and we got paid for it.

One time, we delivered a wedding album and the bride called us filled with excitement. After showing us her favorite photos, she said something we'll never forget: "These are the only good photos I've ever seen of myself." We were surprised. On one hand, we were happy she loved the photos. On the other hand, we thought: *Really!? You've never seen a good photo of yourself before?*

We started noticing that she wasn't the only one. Most people don't have good-quality photos of themselves or the special moments in their lives. They don't have anyone to take good photos for them, and they don't know how to take them themselves. We decided to share our photography knowledge to help people take photos they're proud of, using the devices they already have: their smartphones!

When TikTok became popular in 2020, we started posting simple iPhone photography tips online and they went viral! Our videos got hundreds of thousands of views and we reached one million followers in just four months. It turns out a lot of people want to take better pictures with their phones.

WHY PHONE PHOTOGRAPHY?

Back in the day, you needed fancy equipment and lots of time and money to be able to take a photo. Today, almost everyone has access to a smartphone with an impressive camera, and those who know how to use their phone cameras are getting amazing results. Phone photography is the future, and it's hard for big cameras to compete. Phone cameras are small, they're powerful and they're always with you!

FUN FACT: According to the Worldwide Image Capture Forecast, it's estimated that almost 91 percent of all photos captured in 2021 were taken with a phone camera.

Don't have much knowledge about photography? No problem! You can point and shoot and your phone will do the rest.

Want to take a photo on a rainy day? No worries! Most phones are water-resistant. You can even take your photography underwater, if that's what you're into.

Want to edit your photos without complicated programs or even a computer? Easy! It only takes a few clicks to edit beautiful-looking photos right from your phone.

And the best part is that phones make it so easy to share your photography with the push of a button. If you like a photo and you want to send it to someone, you can do it within seconds from the palm of your hand. If that's not enough, there are always new features and cool apps being released that unlock new abilities so you can take your photography to the next level. It's like getting a brand-new phone without paying for one.

WHO IS THIS BOOK FOR?

There's plenty of photography knowledge spread all over the Internet. The problem is exactly that: It's spread all over the Internet (and only some of it is of quality). That's why we've written this book. We wanted to put together the years of learning we had to go through in an organized, fun-to-read book. This book will save you time and make sure you're getting the best knowledge possible.

This book is for beginner- and intermediate-level learners of all ages who want to improve the photos they share with their friends and family and the ones they post on social media. If you have a phone and you like taking photos, this book is for you. If you like photography and you're interested in learning more without buying expensive equipment, this book is for you. If you want to add a dash of creativity to your photos instead of taking the same "okay" shots, this book is for you.

You'll learn how to take stunning photos of your everyday life and while on vacation. You'll learn how to make people look good, how to understand lighting and how to use the elements in your scene to turn what seems like a boring moment into a piece of art.

BEFORE YOU START READING

This book is full of simple and effective ways to improve your photography in most settings. It's a great start if you want to get into photography as a hobby or for work.

As you know, practice makes perfect. Throughout the book, you'll find Photo Challenges (compiled on page 157) designed to help you take the ideas you're learning and apply them in a creative way. Our advice is: Complete the challenges! That's the best way to improve as a photographer.

And here's something we're proud of: Every photo in this book was taken with an iPhone camera.

It's important to note that we'll be using the words "photo," "picture," "shot," "image" and "frame" interchangeably to refer to what you're seeing on your phone's screen.

You might be wondering . . .

Which Phone Is Best for Photography?

The one you already have! It sounds cliché, but it's true. How you use your phone camera is way more important than its brand or the year it was released. All the photos in this book were taken with an iPhone 11 and 13 Pro. If you have an older iPhone model or an Android device, don't worry. There might be certain differences in the capabilities of the phone itself and/or how to access certain features, but once you figure out how your device works, the ideas we present will work exactly the same and will make your photos look more professional.

Do I Need to Buy Any Other Equipment or Applications?

No. You might've seen a photographer using fancy lenses and lighting gear, but you won't need any of that. We've designed this book to take advantage of natural light and the capabilities of your iPhone's camera straight out of the box.

Do I Need Any Experience?

Whether you've been into photography for a while or you're just starting, you can take incredible photos. All you need is a set of techniques that all great photographers use. We'll teach you everything you need to know to capture beautiful photos you're proud of and to turn your phone into a creative memory-making machine.

 # GETTING STARTED

*An Introduction to Your iPhone Camera and
Basic Principles of Photography*

Apple and other phone companies would like you to believe that
you need to buy the newest phone to get the best photos. While
newer technology can definitely help, it's only a small part of the
story. Regardless of which iPhone model you have, by knowing
the different settings available, you'll be able to take full
advantage of your phone's capabilities.

USEFUL SETTINGS THAT WILL MAKE YOUR LIFE EASIER

Burst Mode

The white shutter button has some hidden features. If you drag the shutter button to the left (or down if you're holding your iPhone horizontally), your iPhone will take many pictures back-to-back. If done correctly, a number will appear counting up the photos captured for as long as you keep holding down the button. This is called burst mode. It allows you to capture a moving subject and later select which moment you like best. Your iPhone will store all of the shots taken as one group (or Burst) in your Photos app. To select the one(s) you like, open the Burst in your Photos app and click Edit. You'll be able to scroll through all the frames captured and select your favorites.

PRO TIP: To get sharp burst photos, make sure your scene is bright.

PRO TIP: If you hold or drag the shutter button to the right (or up if you're holding your iPhone horizontally), your iPhone will start recording a video. It's a useful shortcut that can help you capture fleeting moments you might otherwise miss.

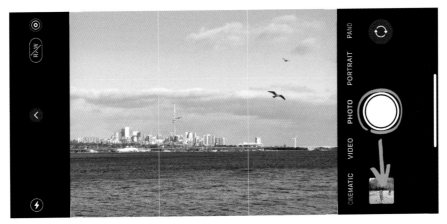

Activating burst mode

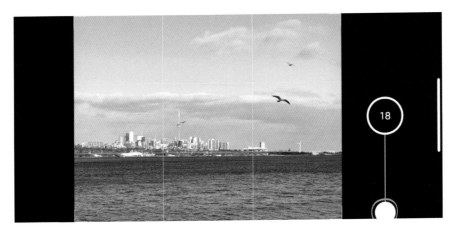

A counter showing the number of photos taken

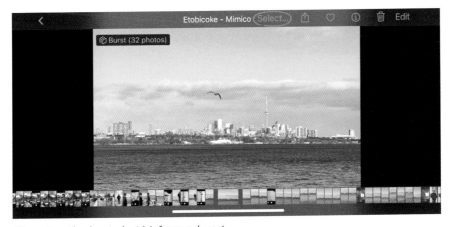

Choosing the best shot(s) from a burst

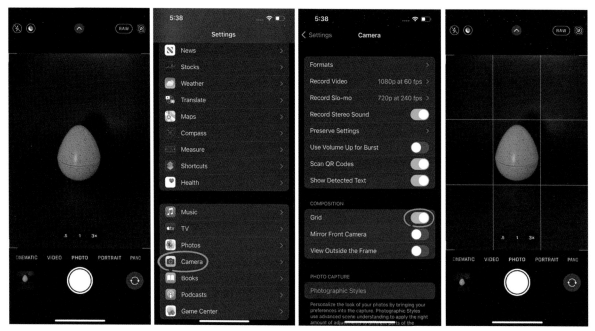

Turning on your camera grid

Live Mode

With live mode, your iPhone will record a one-and-a-half-second video before and after you take the shot. You end up with a photo and a short video attached to it. It's a fun way to capture the moment and add life to your photos. You can click and hold a live photo in your gallery to play the video. We will learn how to use live mode creatively in "The Selfie" chapter on page 133.

Camera Grid

People often take pictures without thinking about the elements in their shot and where to place them. They end up with pictures that are tilted, weirdly cropped or with a person stuck on the side of the frame.

Your camera grid is your best friend when it comes to organizing your scene. It divides your frame into thirds—vertically and horizontally—and helps you position the elements you're seeing on your screen.

To turn it on, go to your phone's Settings > Camera > Make sure your Grid toggle is turned on.

In the "Framing Your Shot" chapter (page 71), we'll dive deeper into the different ways you can use this grid to create a variety of powerful images.

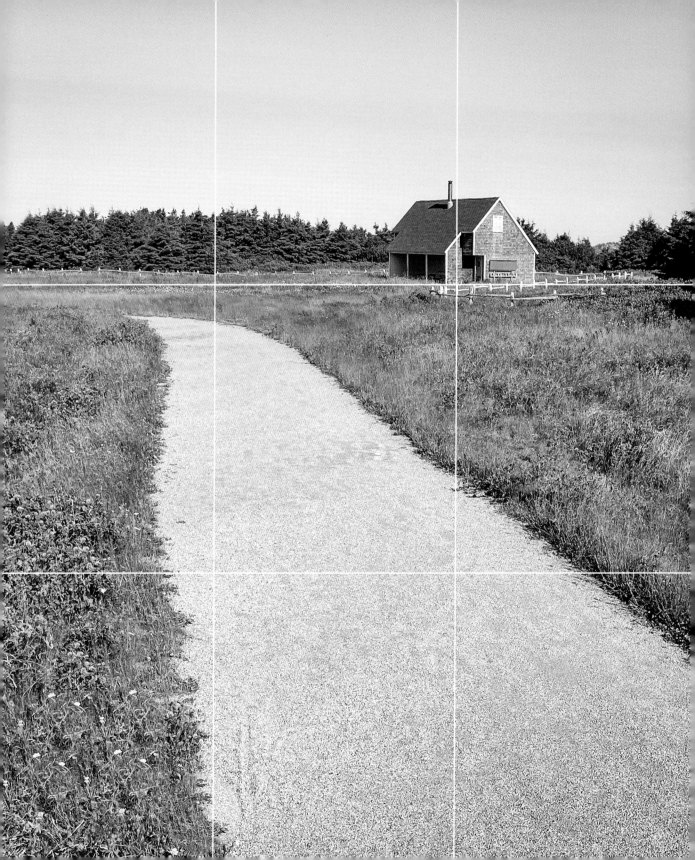

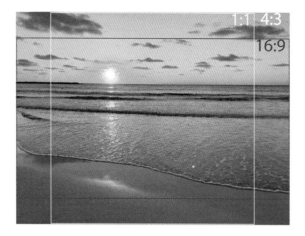

Aspect Ratio

Aspect ratio is a fancy term referring to the relative height and width of your photo. The standard for most phones is 4:3. iPhones give you two more options: 1:1 and 16:9. The 1:1 ratio gives you a square image that is perfect for Instagram posts, while 16:9 allows you to take wider images that fill your entire screen. It's important to note that 16:9 photos are not capturing more of the scene. Your phone simply takes a standard 4:3 photo and crops it in a little bit to show you what the full-screen version would look like.

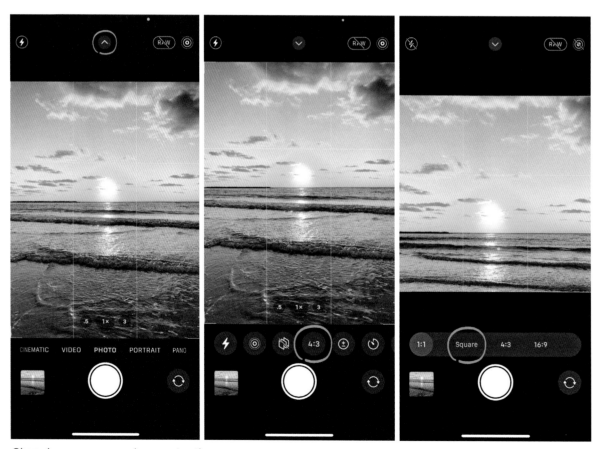

Changing your camera's aspect ratio

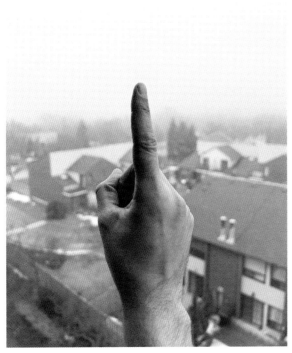
Camera focus on the hand

Camera focus on the background

HOW TO GET SHARP PHOTOS

Close one eye and hold your finger in front of you. Focus on your finger and notice how everything behind it becomes blurry.

Now, without moving your finger, focus your eyes on something in the background, and notice how blurry your finger becomes. Just like our eyes, cameras can't focus on everything at once; they can only have a certain "slice" of the scene in focus. To visualize the slices, look at the diagram on the right.

Notice how each slice is at a different distance from the lens. When a point is in focus, everything at the same distance from the lens (within the same slice) will be sharp. The farther something is from that slice, the blurrier it will be.

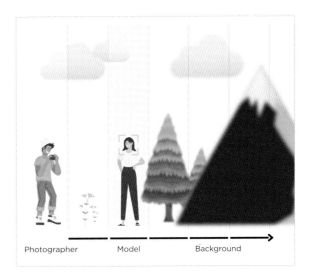

Photographer Model Background

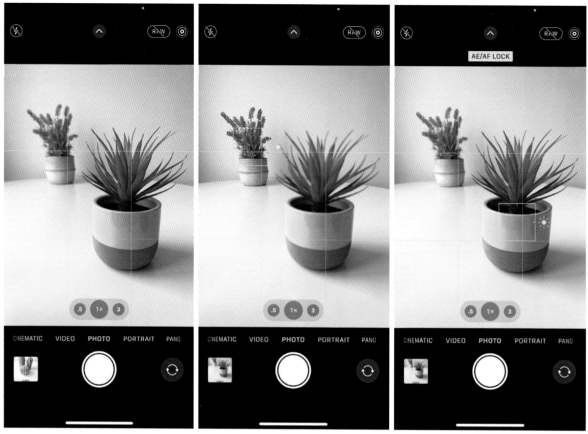

Selecting and locking your camera focus

Lock Your Focus

Every time you open your camera, your phone will try to guess which part of the scene is the most important and will focus on that by default (usually in the center of the frame or on someone's face). To change that, before taking a picture, tap on the part of the image where you want the focus to be and take the shot. Keep in mind that your phone will automatically go back to its default and refocus after a few seconds.

If you want your phone to stop changing the focus on its own, tap and hold a point on your screen until the focus square flashes and the yellow AE/AF LOCK banner appears at the top. This is called locking the focus, and it tells your phone to stop changing the focus and the brightness of the scene.

A stable camera results in sharp photos

A moving camera results in blurry photos

Stay Still

Moving while taking a picture is like trying to read while moving your head. It can work, but details will get a little blurry.

To get sharp images, you want to be as still as possible while taking the shot. It's normal for hands to shake, so the diagram on the right shows some effective ways to stabilize.

It's important not to move after you select the focus. Why? Because your phone's camera isn't focusing on the object you click on, it's focusing on a slice of the scene at a certain distance away from your lens. If you move your phone after choosing the focus, the sharp slice will move

with you and what you're trying to take a picture of might become blurry. Every time you move your phone, tap your screen to refocus, hold still and take the shot.

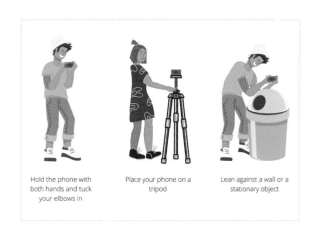

Hold the phone with both hands and tuck your elbows in

Place your phone on a tripod

Lean against a wall or a stationary object

Zooming in digitally results in a lower quality photo

Moving closer to the subject results in a higher quality photo

Zoom with Your Feet

Sometimes you want to take a photo of something, but it's too far away so you end up zooming in using your phone's camera. It's important to know that when you zoom in like that, the quality of your photo drops dramatically. When possible, a much better option is to "zoom with your feet," which means moving closer physically instead of digitally zooming in. It'll take some extra effort, but your resulting images will be sharper with a lot more details. The difference will be most noticeable in dark conditions.

If there's no way to get physically closer and you have to zoom in digitally, try to be as stable as possible to minimize hand shake and help your camera take the best photo possible.

PHOTO CHALLENGE

Take two pictures of a faraway subject. Try taking the exact same shot once by zooming in digitally and another by walking closer to the subject. Notice the difference in quality.

Having enough light results in a clear photo (left), while low lighting results in a blurry photo (right)

Have Enough Light

One of the most common reasons for blurry images is a lack of light. Your phone will do everything to give you a bright image, and if the scene you're photographing is too dark, your phone will try to artificially brighten the image. Think of it as your phone adding "fake" light. This will happen even if you're using the newest phone, and it usually leads to blurry, not-so-sharp images. Notice the difference between the two photos above. By opening the window curtain and allowing more light into the scene, the quality of the photo was dramatically improved. If you want sharp photos, make sure you have enough light! We'll discuss this in detail in the "It's All about the Light" chapter (page 31).

PRO TIP: Make it a habit to clean your lens every time you use your camera. It'll remove any debris, moisture or oil buildup, and it will improve the quality of your photos. Ideally, you want to use a microfiber cloth similar to the one used to clean eyeglasses. If you can't find one, you can also use a soft, lint-free shirt.

Adjusting the brightness of your camera by moving the sun icon

ADJUSTING THE BRIGHTNESS TO FIT THE SCENE

Notice how every time you point your camera at a scene, your phone will try to choose the appropriate brightness to make sure the focus of the image is not too dark or too bright. This could be hit or miss. To control your brightness, tap your screen to pick your focus point, then drag the sun icon up or down. Again, your phone will automatically go back to its default after a few seconds. To stop that from happening, you'll need to lock the focus. To do that, tap and hold a point on your screen until the focus square

flashes and the yellow AE/AF LOCK banner appears at the top. Now you can move the sun icon to adjust your brightness, and your iPhone will not change it.

PRO TIP: Your iPhone will do some processing after you take a shot, and the final image will look a little different. Experiment with different levels of brightness and compare the photos to see what you like best.

Adjusting the brightness of your camera through the dedicated menu button

Another way to gain more control is to adjust the brightness through the dedicated menu button. To do that, tap the arrow at the top of your screen to reveal additional tools, click on the brightness icon (a circle with a +/- in the middle) and swipe your finger left or right to control the slider.

This way you don't have to worry about readjusting the brightness every time you change the focus.

It's important to note that adjusting the brightness of your iPhone camera is only one part of the lighting equation. In the "It's All about the Light" chapter (page 31), you'll learn how to find the best source of light (both indoors and outdoors) and where to place it to create eye-catching photos.

Low-quality photo zoomed in at 2.9x magnification

High-quality photo captured using the 3x (telephoto) lens

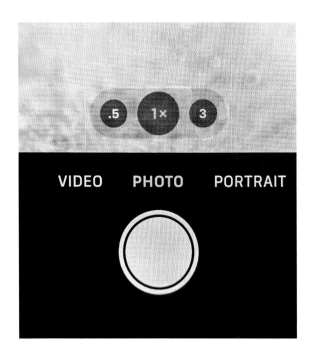

CHOOSING THE RIGHT LENS FOR YOUR SHOT

You might've noticed that new iPhones come with multiple back-facing camera lenses. Each lens has unique strengths and is best used in certain situations. Depending on your iPhone model, you might have a wide angle lens (1x), an ultra wide angle lens (0.5x) and a telephoto lens (2x/3x).

Many people think those symbols are different zoom levels, but that's not the case. As we mentioned, zooming lowers photo quality. When you choose one of the options at the bottom of your camera app (0.5, 1, 2 or 3), your phone is switching between different lenses and keeping the quality as high as possible. Try to only use those values and nothing in between. If you use any other value, your phone will zoom in and the quality will significantly drop. Notice the difference between the low-quality zoomed in photo at 2.9x magnification and the high-quality photo captured using the 3x camera lens.

Photo captured with 1x (wide) lens

Photo captured with 0.5x (ultra wide) lens

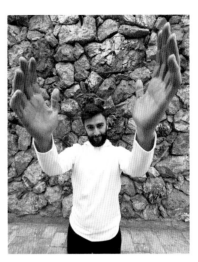

0.5x (ultra wide) lens distortion

PRO TIP: The 1x wide lens has the highest resolution and gives the sharpest photos. Luckily, this lens is available on every iPhone. If your iPhone is missing some of the other lens options mentioned, don't worry! You can still capture incredible photos with one lens.

Since the 1x lens gives the highest quality photos, it's the lens you should be using most often. The wide and ultra-wide lenses are very useful when you want to show more of your scene, but you're unable to take a step back.

One thing to keep in mind is the wider the lens, the more stretched out (or distorted) the image will be. The distortion is most noticeable closer to the border of the image, so it's a good idea to keep human subjects in the center of the frame to avoid stretched-out faces and limbs. Having said that, you could use the distortion to create fun exaggerated photos like the one above.

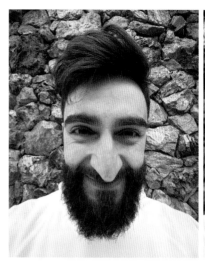
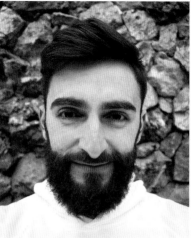

Photo captured with 0.5x (ultra-wide) lens standing very close to the subject

Photo captured with 1x (wide) lens standing close to the subject

Photo captured with 3x (telephoto) lens standing far from the subject

Lens distortion can easily be seen in human portraits because it dramatically changes the shape of a person's face. It can make certain features appear larger and more stretched out. Take a look at the example above, where we took the same shot of Yasseen's face using the three different lenses on our iPhone (0.5x, 1x and 3x).

The telephoto lens (2x/3x) is usually recommended for taking photos of people because it makes facial features appear smaller, which tends to be more flattering. It's also a great lens when you're unable to move closer to your subject or when you want to simplify your scene by including less in your shot.

PRO TIP: When using a telephoto lens, things in the background of the image will appear larger and closer to the subject than they are in real life. Use it when you have a nice background to emphasize and you want to show more of it.

PHOTO CHALLENGE

If you have multiple lenses on your iPhone, pick a subject and take a picture of it using each lens. Try to keep your subject the same size in the frame by moving closer to or farther away from it. Notice the difference between the shots.

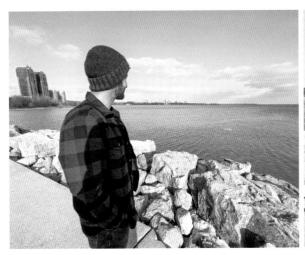

Photo captured with 0.5x (ultra-wide) lens standing very close to the subject; the city skyline is not visible

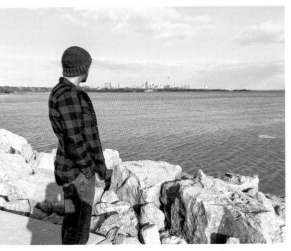

Photo captured with 1x (wide) lens standing a few steps away from the subject; the city skyline appears small and far away

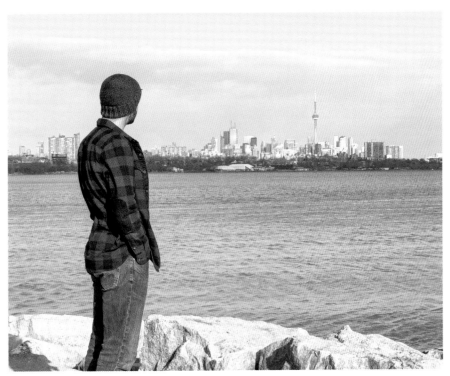

Photo captured with 3x (telephoto) lens standing far from the subject; the city skyline appears larger and closer to the subject

☀ IT'S ALL ABOUT THE LIGHT

Control It and Turn Every Shot into a Masterpiece

When people take a picture, they almost never stop and think, *Where is the light coming from?* or *What kind of light would make this better?* By turning around or taking a few steps, the same shot can often become ten times better. In order to learn how to take quality photos, we have to start seeing the world the way our cameras do.

Not having enough light on the subject's face lowers the quality of the photo

Having lots of light on the subject's face results in a high-quality photo

FINDING THE "REAL" LIGHT

Here's a fun experiment: Pull out your phone and turn on the camera. At first glance, everything is lit. Congratulations! You have found the light; it's everywhere. But wait, it's not that simple. We talked about how phone cameras would do anything to avoid taking a dark photo, even if it means adding artificial, or "fake", light and lowering the quality of the image. How can you avoid that? Well, you have to start looking for the "real" light.

Technology has advanced so much that your phone camera is always analyzing the scene and trying to guess the appropriate brightness. However, you're smarter than your smartphone.

Try this:

When you're at home during daylight, turn off the lights, pull out your phone, open the camera app and switch to the front camera. Now, stand next to a window and start rotating slowly while keeping yourself in the center of the screen.

Notice how the light and shadows on your face change as you move. Try getting close to the window, placing it behind you, in front of you, to the side, etc.

You'll also notice how the photo quality changes depending on the amount of light shining on your face.

This is the best way to learn lighting. You can do the same exercise walking indoors or outdoors, and you'll start understanding how the light affects your subject in different situations.

NOT ALL LIGHT IS CREATED EQUAL

Before we jump in and start talking about those fancy lighting effects you see in movies and fashion magazines, we need to understand light a little more. There are two main types of light: soft light and hard light (also known as harsh light). What are they? How can we use them? Which one is better? Let's find out!

Soft light gives soft shadows

Hard light gives sharp shadows

Soft Light

Soft light is light that tends to "wrap" around objects and illuminate them evenly. Think of the light outside on a cloudy day. It creates diffused shadows with soft edges and is generally very pleasing to the eye.

Hard Light

To put it simply, hard light is concentrated, focused light that is usually super bright. Think about the midday sun or a small flashlight directed at someone's face. Hard light creates sharp shadows and defined lines between the dark and bright parts of your image.

Which One Is Better?

Well, it depends! Most people consider soft light to be the clear winner. It gives beautiful, flattering results and is much easier to work with. That's why photographers love taking pictures on cloudy days. On the other hand, hard light is bold and creative. It creates a dramatic, artistic look that gives you more interesting results. At the end of this chapter, we have an entire section exploring the different ways you can use hard light to create moody, powerful images that will catch your viewers' eyes.

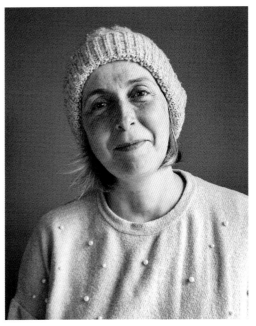

Side-lit photo using a window placed beside the subject

Front-lit photo using a window placed behind the photographer.

CHOOSING THE DIRECTION OF THE LIGHT

Beginner photographers rarely pay attention to the direction the light is coming from. The problem is, even if the scene is pretty, if the lighting is bad, the photo will be bad. The direction of the light is just as (if not more) important than the type of light you rely on. Let's talk about the different options available: front-, back- and side lighting.

Frontlighting

The simplest option is to have the light coming from the same direction as the camera. That way, you can easily make sure that enough light is hitting the scene. Frontlighting minimizes shadows and evenly lights your shot. It works beautifully with soft light on cloudy days, during golden hour or indoors using a window.

PRO TIP: Golden hour is the magical time after sunrise or before sunset when the sun is low in the sky, casting smooth shadows and creating a warm, soft glow. See page 45 for more information about golden hour.

Light behind your subject results in their face being dark

Light in front of subject results in their face being bright

If you're taking a photo of someone, frontlighting smooths out the skin and hides imperfections. That's why it's the most common setup for fashion portraits, makeup artists and high-end magazines. Do yourself a favor and take your family portraits using frontlighting; it will definitely earn you bonus points with your grandparents.

Frontlighting is also very useful when taking a selfie (or joining a video call). It makes your face brighter than the background, which improves the quality of the shot and is a lot more flattering. Notice the difference between the two photos above!

PHOTO CHALLENGE

Go out and capture a front-lit portrait. Make sure the light is soft by going on a cloudy day or during golden hour. Move your model around and position them in a way that gets rid of any shadows on their face.

Backlighting

Backlighting is one of the most useful techniques that people don't know about. It can be used for natural and artificial light and gives jaw-dropping photos every time—for both human and nonhuman subjects. The name says it all. Place the light source behind your subject when taking their photo.

It's especially useful when you're taking a picture of someone outside and the sun is high in the sky, directly hitting them from above. To remember this, think: "When the sun is high, have your subject face their shadow." By doing that, the back of their head blocks the sun, their face is in the shadow and they're able to comfortably open their eyes. It also creates a beautiful outline of light around them, separating them from the background.

PRO TIP: The most common mistake people make when taking a portrait of someone is having the light shining on the subject from up above. It happens indoors with ceiling lights and outdoors with midday sun. The subject ends up squinting and having unflattering dark shadows under their eyes (also known as raccoon eyes). You always want to avoid raccoon eyes.

Sun flare, with the sun directly hitting the lens

No sun flare, with the lens in the shadow

Block the sun with your hand to keep your lens shaded

One issue you might run into when taking a backlit picture is sun flare. When the sun directly hits your camera lens, your photos will be washed out with faded colors and blurry details. To avoid that, make sure the sun is out of your frame or blocked by your subject. And, if you can, try blocking the sun with your hand to keep your lenses in the shade.

PHOTO CHALLENGE

Go out with a friend on a sunny day and take a backlit photo of them. Try placing the harsh sun on their face and then walk around and place it behind them. Notice the difference.

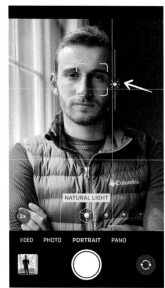

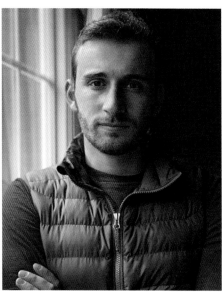

This subject is side-lit using a window with the brightness lowered to create a dramatic shadow

Side Lighting

When the light is hitting your scene from the side, your photo will have a lot of contrast with a big difference between the highlights and the shadows. This setup creates the most dramatic shadows and brings out the texture of your subject. It's especially good for creating moody shots and adding emotion.

PRO TIP: In photography, highlights are the brightest parts of your photo and shadows are the darkest parts of your photo.

For the example above, we placed our model next to a window so that their face is lit from the side. Before taking the shot, we clicked on the model's face to lock focus and drag the little sun icon down to lower the brightness.

Another thing to note is that you can control how much the light "wraps" around the model's face by slightly turning them toward or away from the window. If you want more shadows, turn them away from the window, and if you want less, turn them toward it.

PHOTO CHALLENGE

Find a lamp with a removable shade and place it on the side of your face. Take a selfie with the shade on (soft light) and then without it (hard light). Notice how the shadows change.

MAKING THE MOST OUT OF SUNSHINE

Now that we understand light a little more, let's talk about the magical light source Earth is orbiting: the sun. Natural-light photography is using the sun as your light source. For most photographers, natural light is the best light, and there are many reasons for that. Sunlight is pretty, it enhances colors and skin tones, and it's available to everyone.

Sunlight also changes throughout the day, and it's important to learn how to take advantage of it.

Golden Hour

During the first and last hour of the day, the sun is low in the sky and the light is soft and colorful. It's a great time to have your model face the sun to give them the warm, soft look everyone loves. You can also use the colorful sunrays to back-light your subject, giving them a beautiful golden outline.

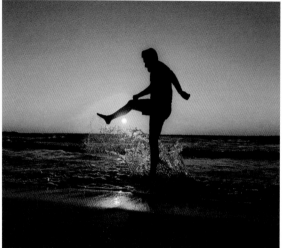

Creating silhouettes

Another fun way to take advantage of golden hour is to capture silhouettes. Try to place your subject against the bright, colorful sky, and make sure nothing is intersecting with their body. Click and hold on them to lock focus, then lower the brightness to turn your subject into a silhouette and reveal more details in the sky.

PHOTO CHALLENGE

Plan a photo shoot during golden hour where you capture a front-lit golden portrait and a creative silhouette.

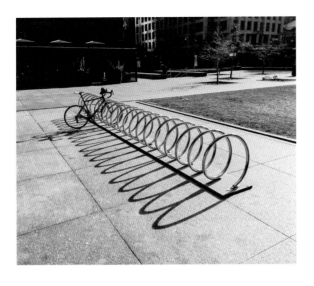

High Sun

When the sun is high in the sky, the shadows are defined and the lines between light and shade are sharp. This is what hard light looks like.

Lots of people struggle when taking photos in these conditions, but it's simpler than you think. To create powerful images, all you have to do is embrace the contrast by showing the difference between the bright and the dark areas of your scene.

Find an angle that includes both highlights and shadows, then lower the brightness to exaggerate the difference between the two.

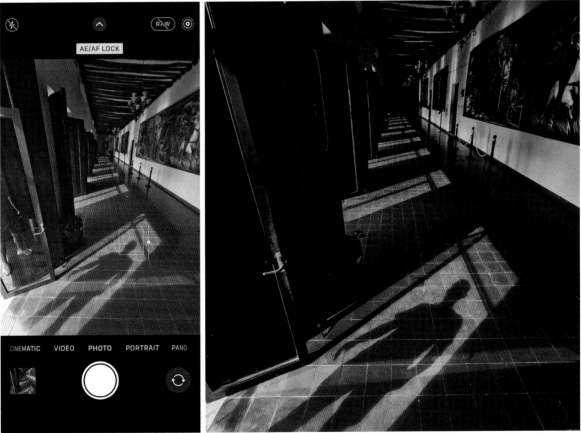

Lowering the brightness increases contrast

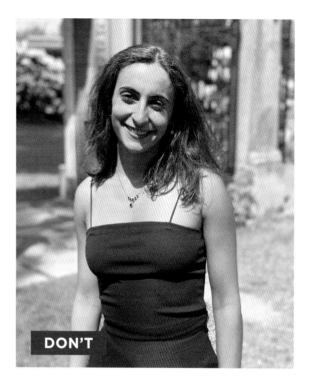

DON'T

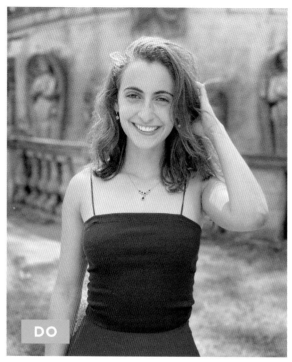

DO

As we mentioned earlier, when photographing people in high sun, the biggest problem you might run into is raccoon eyes. Notice how in the first picture, our model has very harsh shadows under her eyes. To fix that, we can simply turn her around and have her back facing the sun. That way, her face is evenly lit and her hair has a golden outline helping her stand out from the background.

The sun doesn't have to be exactly behind the subject. As long as the sun is not directly hitting the person's face, you'll be able to avoid the harsh shadows.

Pro Tip: When taking a picture of someone close to midday while the sky is very bright, try not to include too much of sky. It could work, but the bright sky usually looks like empty white space and can distract from your subject.

Backlighting works well, but it also limits the angles from which you can take the picture. You might find yourself in a situation where you want to take a picture in front of a particular background, but the sun is not cooperating. In that case, you can have your model wear sunglasses, look into the sun and close their eyes, or have them create their own shade with a hat or an umbrella.

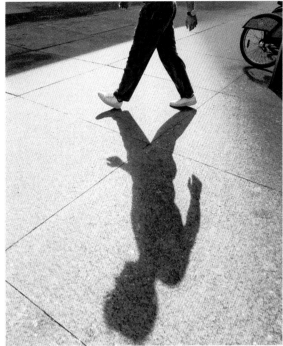

Another fun option is to look for interesting shadows to add to your photos. Harsh sunlight might not be easy, but it can allow for creativity. Try using different objects to create interesting shadows and cool effects. You can use tree leaves, fences or anything else you can think of.

Black and white usually looks great with hard light, because it empathizes the dramatic difference between light and shadow. However, you can experiment with color and get some amazing results.

PHOTO CHALLENGE

On a sunny day, capture a creative hard light picture using a common everyday item (e.g., a leaf, a comb or a strainer) to create interesting shadows.

Cloudy Days

Photographers love cloudy days because they're easier to work with. The light is soft and even, and there's barely any shadows to worry about. For the most part, no matter where you point your camera, you will end up with soft, evenly lit subjects.

Since the light is mostly the same from every angle, you'll be able to focus on composing your shots, which we'll talk about in the next chapter (page 71).

PRO TIP: Remember, the sun is still somewhere behind the clouds and the direction of the light can make a difference depending on the cloud coverage.

TAKING PICTURES AT NIGHT

Night photography is a great way to get some unique shots. It allows you to avoid the daylight crowds and lets you capture the world in an unusual way. Darkness changes everything. Sometimes the same boring location is transformed into a masterpiece when shot at night.

Your iPhone doesn't like darkness and will try to artificially brighten the scene. We find it's usually better to manually darken the image or, as we like to say, "Let night be night." Your resulting photos will be sharper and will communicate the true feeling of the place you're in.

Pick a bright subject to photograph. Lock the focus and lower the brightness to hide the parts of the frame you don't care to show. Make sure you're as stable as possible to help your phone capture sharp photos with the limited light available.

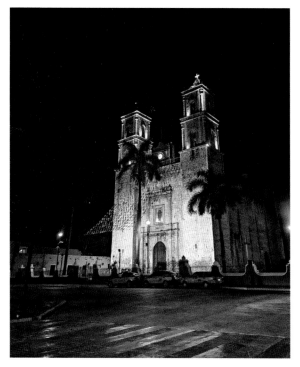

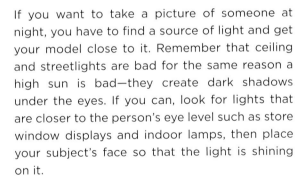

Indoor night photo next to a lamp

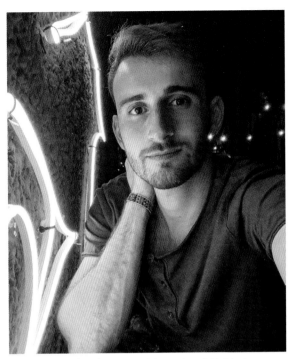

Outdoor night photo next to a street light sign

If you want to take a picture of someone at night, you have to find a source of light and get your model close to it. Remember that ceiling and streetlights are bad for the same reason a high sun is bad—they create dark shadows under the eyes. If you can, look for lights that are closer to the person's eye level such as store window displays and indoor lamps, then place your subject's face so that the light is shining on it.

If you really can't find any light, use your iPhone's camera flash, but keep it as a last resort. A camera flash makes the person look flat, but it's better than not being able to see their face.

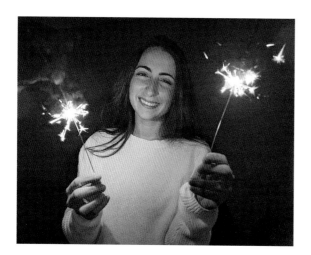

You can also include your own light source, such as fairy lights, candles, sparklers, etc. They'll add a fun element to your shots, and you'll be able to add light exactly where you need it.

To create the colorful shadows, we had three flashlights (red, green and blue) pointing at our subject at the same time. The mixing of the colors results in the colored shadows you see in the shot. You can experiment with different colors or use only one flashlight to keep things simple.

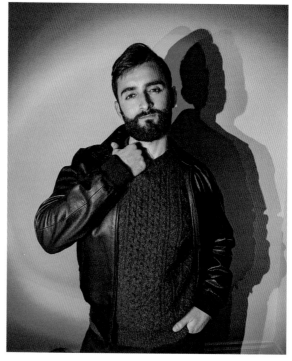

PHOTO CHALLENGE

Go out and capture the city lights at night. Remember to let night be night and be in control of your camera's brightness.

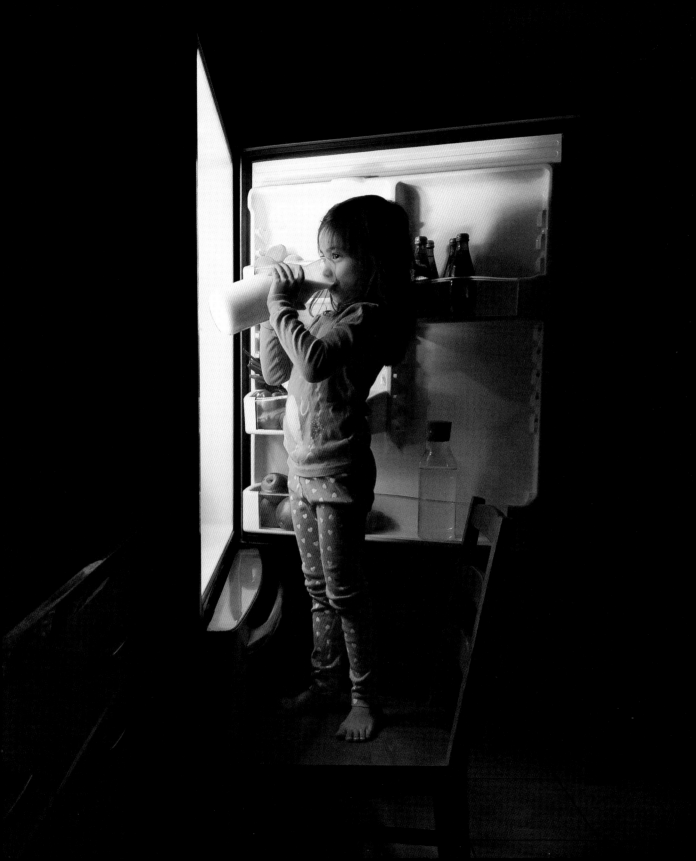

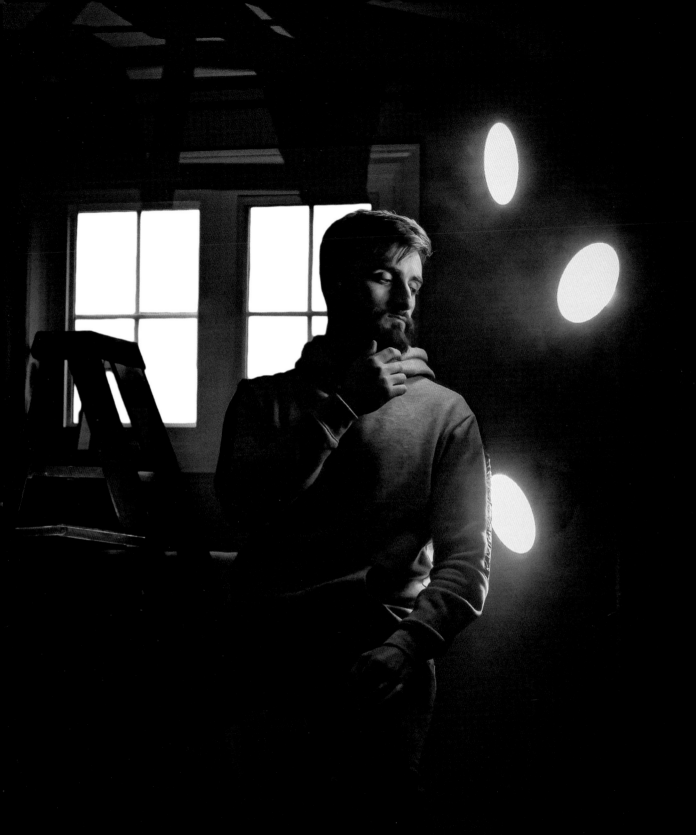

PLAYING WITH SHADOWS FOR DRAMATIC LIGHTING

We've talked a lot about proper lighting and how we can use it to create visually pleasing photos, but now it's time to embrace the dark side. We love this section of the book because we get to create photos that seem unreal. Lighting can really set the mood for our photos, and that's exactly what we're trying to do here.

In traditional photography, the goal is to capture life the way our eyes see it—to have everything properly lit. With dramatic lighting, the goal is to highlight the brightest part of the scene while darkening everything else. This will help you shoot attention-grabbing photos by giving you full control of what you want to show and what you want to hide. It directs the viewers' eyes toward the most important part of the scene while eliminating all distractions. Dramatic lighting can be used with any kind of photo, but in this section we're going to have fun with portraits.

Photographers usually run away at the thought of hard light. That's why you hear everyone talking about "golden hour" as the magical time to take photos with the soft sunrays. It's for a good reason. Soft light is easy. It makes people look good, and it doesn't take much effort to photograph. On the other hand, hard light is more challenging to capture, especially in portraits because it creates intense shadows. In this section, you'll learn how to embrace hard light and you'll start getting excited every time it crosses your way.

REMINDER: Hard light (as opposed to soft light) is direct bright light that creates defined shadows with sharp lines. Think of the intense light on a sunny day or a flashlight directed at someone's face

Choosing Your Source of Light

Okay, so what type of light do we want to use? When it comes to creating dramatic shadows, the simplest and most obvious source of hard light is the unobstructed sun on a clear day. Cloudy days don't work as well for our purposes; the clouds soften the light, making the shadows and highlights much more blended together. It's pretty, but there's not much drama.

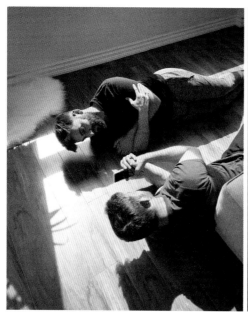

Behind the scenes of using the sun to sidelight the subject

Bright original photo

Lower the brightness to achieve the dramatic look

Using the Sun

The sun is great, but it has one problem: It usually illuminates every part of the scene equally. Your job is to find a location (or an angle) that has a spot of intense light right next to a darker background. Ideally, you'd want the sun to be hitting your subject from the side and casting harsh shadows in your shot. Windows are the easiest way to do that.

Take a look at the example above. Notice that the background behind the model is in the shade and is much darker than his face. That's why it completely disappeared when we lowered the brightness of the photo. If you try this and the person disappears with the background, it means they both have the same brightness. To fix that, find a darker background or a brighter spot for your subject.

GET CREATIVE! The reason we were on the floor in the example above was because we wanted the sun to side light Yasseen's face instead of shining from above. Side lighting increases contrast and is perfect for this kind of dramatic shot.

iPhone cameras are smart and are programmed to show the entire scene, but that's not what we want here. We want to highlight the brightest part of the shot while darkening everything else. To do that, simply click and hold on your model's face to lock focus and drag down the sun icon to adjust the brightness. Notice how once we do that, everything disappears except the right side of his face.

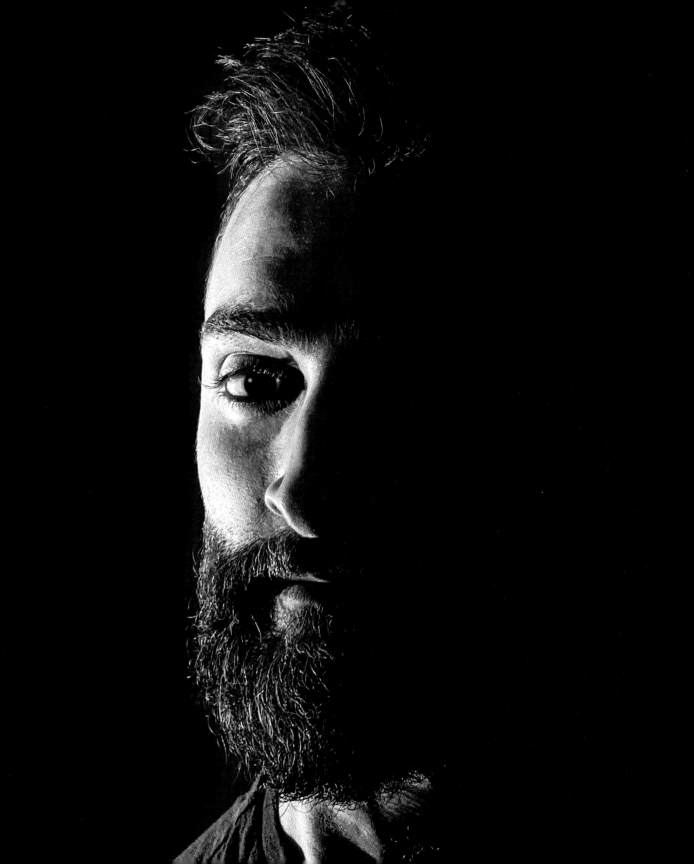

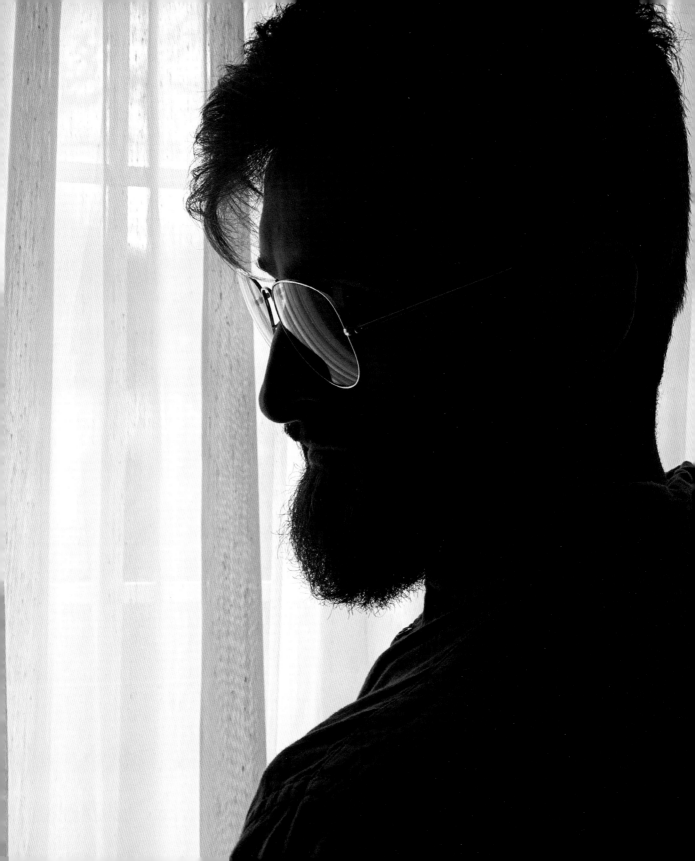

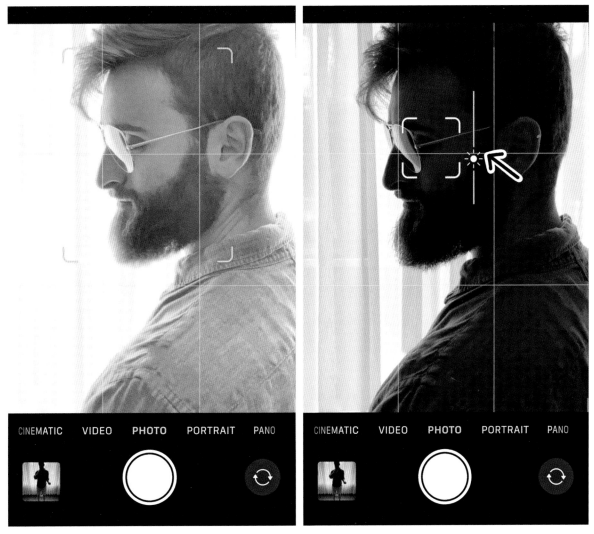

Lower the brightness to create a silhouette

Creating Silhouettes

Another cool idea is to use a bright background (such as a window) to silhouette your subject against. Simply frame your model within the brightest part of the scene, lower the brightness and snap away! Bonus points if you include a prop (such as glasses) that would add color and three-dimensional texture to your image.

PRO TIP: Notice how the curtains add shape and texture and create a more interesting background for our subject.

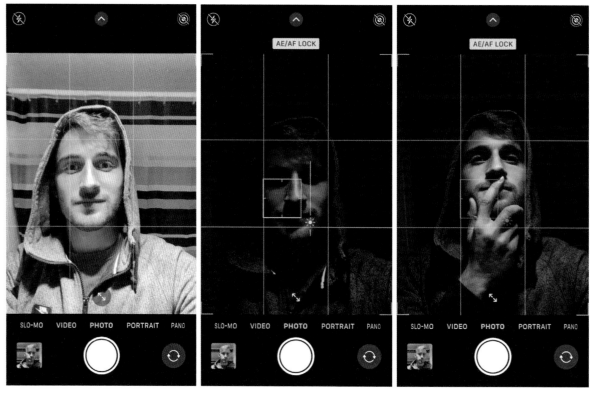

Lower the brightness to make the background disappear

Using Artificial Lights

Next, let's use an artificial source of light to create a similar dramatic effect. The benefit of flashes and lightbulbs is that they're easy to move to get the desired look. All you need is a strong light and a relatively dark area. For this example, Moaz stood under a bathroom light, clicked on his face to lock the focus and dragged the sun down until the shot was dark enough and the background disappeared. While doing that, he noticed that his eyes weren't showing, so he looked slightly up and added his hand to complete the pose.

PRO TIP: If you try this and your face disappears with the background, get closer to the light, get a stronger light or go to a darker area.

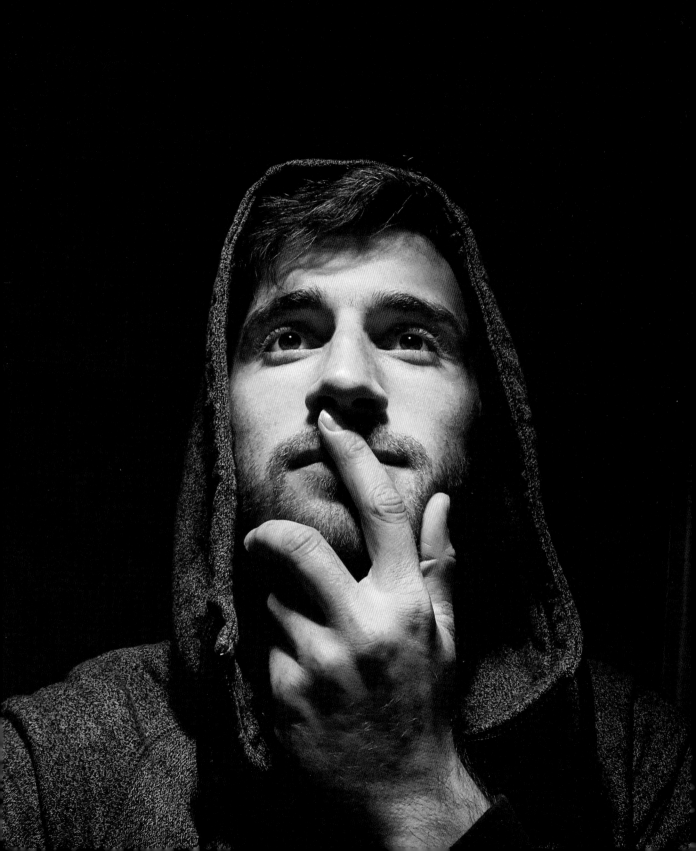

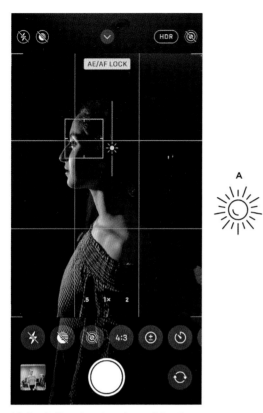

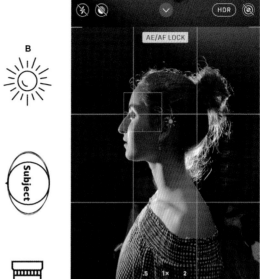

Light A illuminating the subject's face

Adding Light B creates a rim light and separates the subject from the dark background

Adding Rim Light

Let's spice things up. Bring two lights and position them like the picture above: (A) toward the model's face and (B) directly on the opposite side of the camera, hidden behind the model. (A) will light the model's face and (B) creates a beautiful outline of light around her body, called rim light, separating her from the dark background.

FRAMING YOUR SHOT

Highlight Your Subject and Avoid Distractions

There are endless possibilities every time you want to take a photo. As a photographer, your job is to choose one of those possibilities and use it to tell the story of your scene and guide the viewers' eyes to the most important part of the photo. Composition is one of the best ways to achieve that.

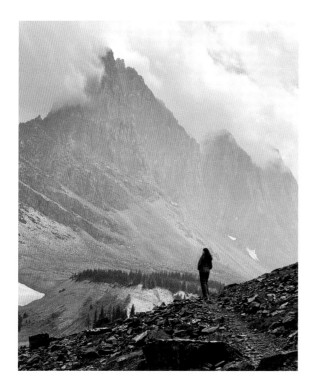

WHAT IS COMPOSITION?

In photography, composition is the way elements in a photo are arranged. In other words, what are the elements in your frame and where are they placed? A good photographer can take those elements and place them in a way that creates more interesting images.

PRO TIP: What is the most important part of an image? It's up to you. It can be anything you want, you just have to find a way to highlight it.

Before we jump in, let's play a game. On the next two pages, you'll see a collection of photos. Look at each one and try to guess the most important part of the photo. What's the first thing that catches your attention?

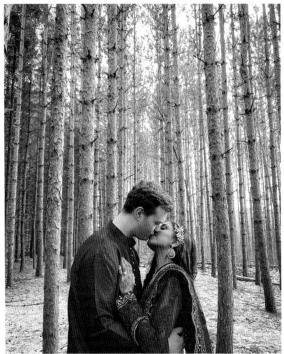

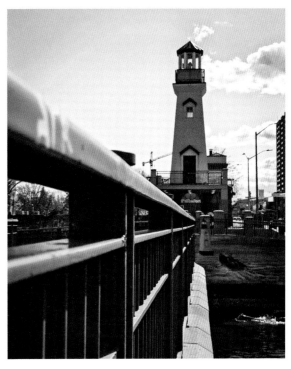

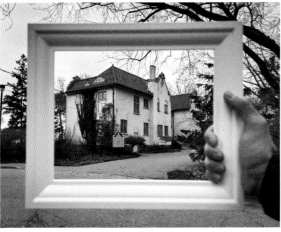

Obvious, right? There's an important element in each photo, and your eyes directly go to it. It's not a coincidence. Your eyes went exactly where the photographer wanted them to go. How did that happen?

Each photograph had one or more compositional techniques that all great photographers use. Let's go over some of them and discover the options you have available every time you take a photo.

LANDSCAPE VS. PORTRAIT

One of the first decisions you have to make when taking a photo is the orientation: landscape or portrait. The main difference between the two is that a landscape image is wide and a portrait image is tall. Both are useful in different situations, but as a rule of thumb, remember this: landscape for scene, portrait for person.

Landscape

As the name suggests, the landscape orientation is perfect for taking photos of natural landscapes and cityscapes because you're usually able to show more of the scene. Imagine you're standing in front of a mountain range with a boring sky above and empty fields below. Taking a landscape photo would beautifully show the wide mountain range while minimizing the not-so-interesting sky above and the ground below.

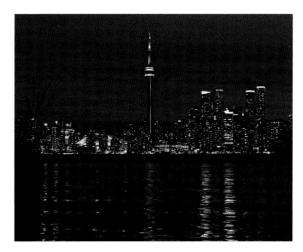

Of course, you can always add a person to a landscape photo. It adds an interesting human element and works really well if you want to show where someone is.

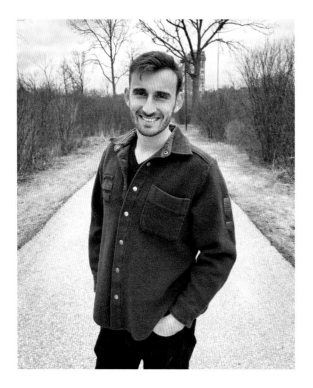

Portrait

The portrait orientation is ideal for taking portraits of people. Generally speaking, a portrait photo is perfect when you don't care to include the environment. It makes the photo all about the person and gets rid of any distractions.

There are also times when a portrait photo works well to capture scenery. That's usually the case when you want to highlight vertical subjects that extend from the top to the bottom of your frame, such as a tree, a long street, a waterfall, etc.

PHOTO CHALLENGE

Capture three scenes that are better photographed in the landscape orientation and another three that would look better as portraits.

PRO TIP: Start taking both portrait and landscape shots every time you photograph a scene. You'll start noticing what looks better and when to use each orientation.

CREATING DEPTH FOR ARTISTIC IMAGES

When you open your eyes, you can immediately tell what's close and what's far. You can see the world in three dimensions. A photo is a flat two-dimensional representation of our rich three-dimensional world.

When everything is in focus, a photo appears flat and lacks the depth our eyes are used to. One of the best ways to re-create this sense of depth is by having different levels of focus in your photo—some parts that are blurry and some that are sharp.

That's why the first thing that comes to mind when people think about "professional photography" is the smooth, blurry background surrounding a model.

Remember, cameras can only have a certain "slice" of the scene in focus. To create depth, include multiple slices in your scene; in other words, things that are far and others that are close. Take a look at the examples on this page:

Photo without depth: The subject is close to background, and everything is in focus

Photo with depth: The subject is far from the background, and the background is blurry but the subject is in focus

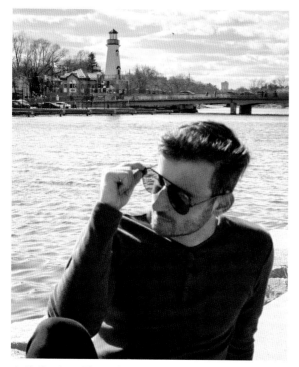

Artistic shot: The subject is blurry and the background is in focus

Background Separation

The easiest way to create depth is by capturing a subject with a distant background. By focusing on a close subject and having everything else far and blurry, you can give your photos a unique three-dimensional feeling. The farther the background, the more separation you will get, and sometimes it's as simple as moving the subject a few steps away from the background.

For a creative result, you can also do the opposite by focusing on the distant background and having a blurry subject.

Your phone will automatically focus on what it deems important. In the lighthouse example, it'll naturally focus on the person, but to be artistic, all you have to do is click on the part of your screen you'd like to focus on (in this case the lighthouse) and your iPhone will adjust.

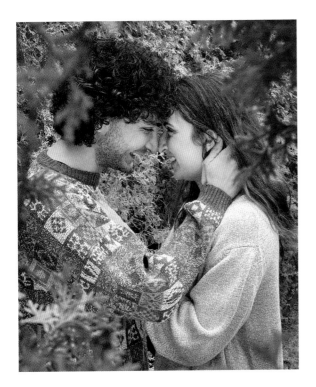

Adding Foreground Elements

The foreground is the part of the photo closest to the camera. By including an element that is close to the lens, it makes everything behind it appear far away and adds a sense of depth to your photo. Look for elements you can include in your photo, such as tree branches, flowers or even a fence.

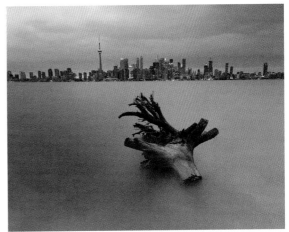

Another fun option is to add your own element close to the lens. It can be a sparkler, a flower or even someone's shoulder.

Try to add elements that would enhance your shot and add to the story. Notice how including the blossoms in the photo above adds a pop of color and gives the photo a cheerful spring feeling.

PRO TIP: Portrait mode is great for creating separation and blurring parts of the photo. We'll talk about it in detail in the "Portrait Photography" chapter (page 101).

PHOTO CHALLENGE

Find a scene where you can create depth by including something in the foreground. Take the shot with and without the foreground element and notice the difference.

THE RULE OF THIRDS

When taking a shot, most people position their subject in the middle of the frame, and they do that every time. The rule of thirds is a useful reminder to mix things up and experiment with different compositions. You can use your camera grid lines as a guide to help you position the elements you see on your screen in a visually pleasing way.

PRO TIP: Check out the "Getting Started" chapter (page 13) for how to turn your camera grid on.

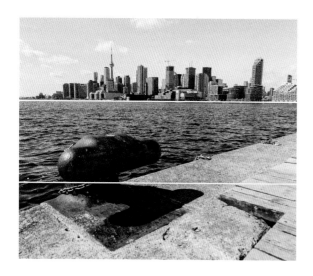

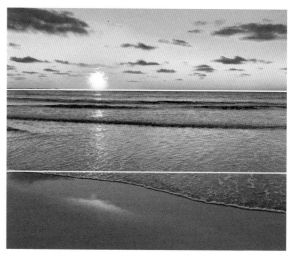

Creating Layers

The parallel grid lines can be used to divide your scene into vertical or horizontal layers.

Notice how the picture of the sunset above has three layers: the sand, the water and the sky. Instead of placing the horizon in the center of the frame, you can try placing it along either the top or bottom grid line. That way, you'll be changing the size of the layers and you'll get a completely different look. Deciding which approach is better will depend on the scene and your personal preference.

Arranging your scene in a way that creates layers is an easy way to make your photos more interesting. You can use the grid lines to divide your scene into thirds vertically or horizontally.

Using the Intersections

By placing the most important elements of your photo at the intersections of the grid lines, you can create balanced photos that are pleasing to the eye and you'll be able to show more of your scene.

To practice using the rule of thirds, capture multiple photos of the same subject, first with the subject in the center and then placed on the different grid line intersections. By doing that, you'll be able to compare the photos side by side and decide which composition you like best.

PHOTO CHALLENGE

Find a landmark or an interesting structure near you and take pictures of it using the rule of thirds. Try placing it on different intersections and choose your favorite one.

SYMMETRY

We have a natural tendency to like symmetry; it feels organized in a way our brains enjoy. The simplicity of a symmetrical scene is relaxing in a way that is hard to describe. Maybe it's because it's an escape from the randomness of everyday life into something that is perfect. To capture this perfection in your photos, you can search for symmetry or you can create it yourself.

Finding Symmetrical Scenes

Whether it's the architecture in a city or the elements out in nature, there's symmetry everywhere and it's just a matter of us finding it.

Once you find a symmetrical scene, make sure you're standing centered with it and hold your phone as straight as possible. Try pointing up, pointing down and moving one way or the other until you find the most symmetrical shot. You don't want any random object to take away from the perfection you're capturing.

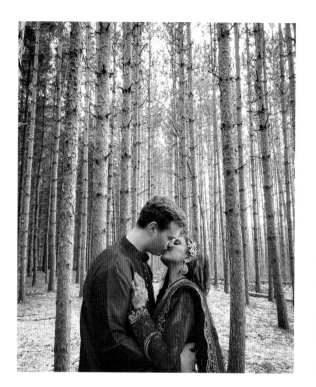

You can also try placing a subject within your symmetrical frame. It creates a perfect background that draws all the attention to your subject(s). Notice how the couple stands out against the simple symmetrical scene.

Creating Your Own Symmetry

Another fun option is to come up with cool ways to produce your own symmetry. That can be done using reflective surfaces (e.g., cars, mirrors, puddles, etc.) or by literally doubling your scene like in the breakfast shot.

PHOTO CHALLENGE

Take a perfectly symmetrical photo. You can look for symmetry around you, or you can create it yourself.

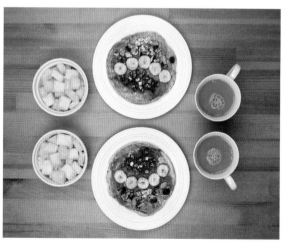

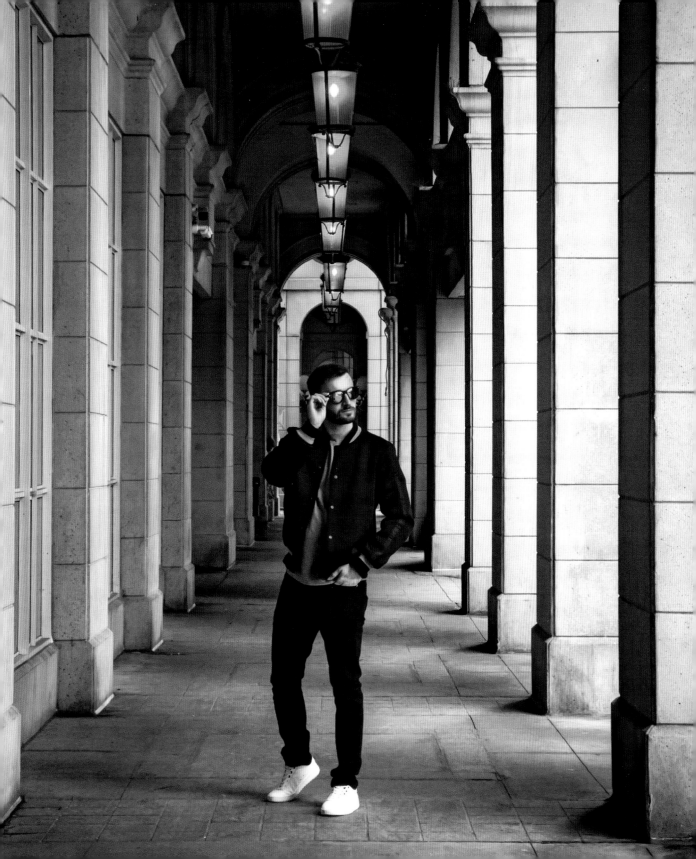

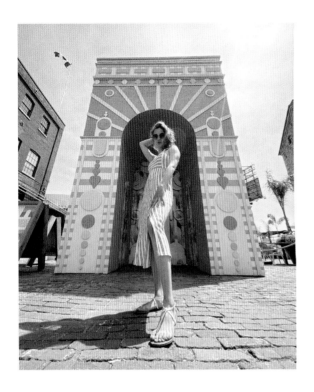

FRAME WITHIN YOUR FRAME

One of the best ways to highlight your subject and direct the viewers' eyes is by using a frame within your frame. What do we mean by that? Find the part of the scene that you can place your subject (frame them) within. It could be a doorway, a bridge or an opening between the trees. It leads to interesting images and makes it look like the entire scene was created for your subject!

Just like with symmetry, you have two options: Find a natural frame or make it yourself!

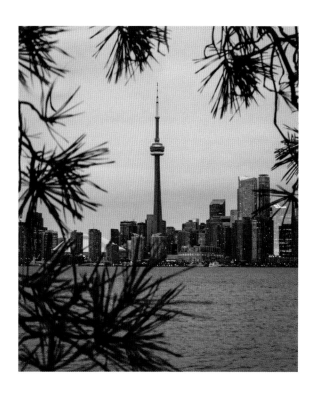

Finding Natural Frames

Let's say you're trying to take a picture of a beautiful building. Instead of taking the shot as is, look around and try to find elements you can place around the building to highlight it.

The easiest natural frames to find are usually tree branches and windows, but when you start looking, you'll realize that any opening can be transformed into a natural frame when photographed from the right angle.

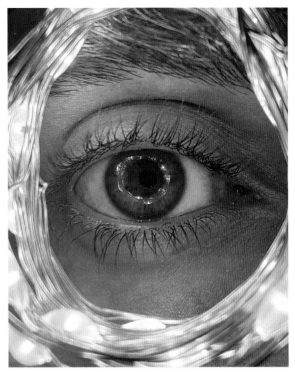

Once you've found a frame, it often takes some experimenting to position it around your subject. Keep in mind that the size of your subject relative to the frame will change depending on the distance between them. Move your subject or the camera to get your perfect frame. You want the frame to highlight your main subject and direct all eyes toward them.

Create Your Own Frame

This is more of a creative option! Use a picture frame, a bracelet or anything you can think of to surround your subject and give them a frame within your shot. You can do this anywhere and the possibilities are endless. Always remember that the frame should never distract from your subject, but, rather, it should highlight them and add to the story of the photo.

PHOTO CHALLENGE

Go out with a friend and take a picture of them using a natural frame in your environment. You can use trees, buildings, doorways or even the clouds. Get creative!

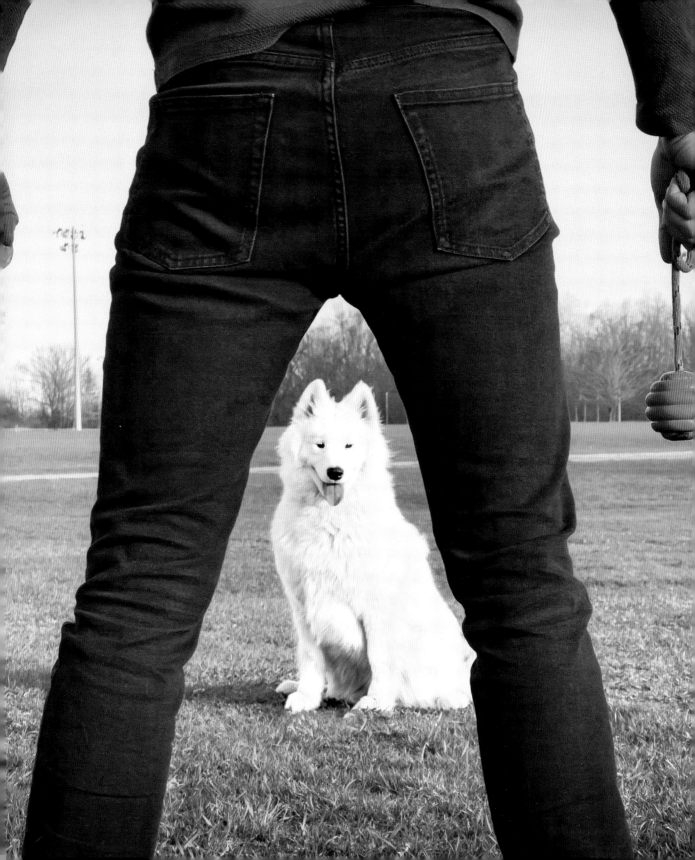

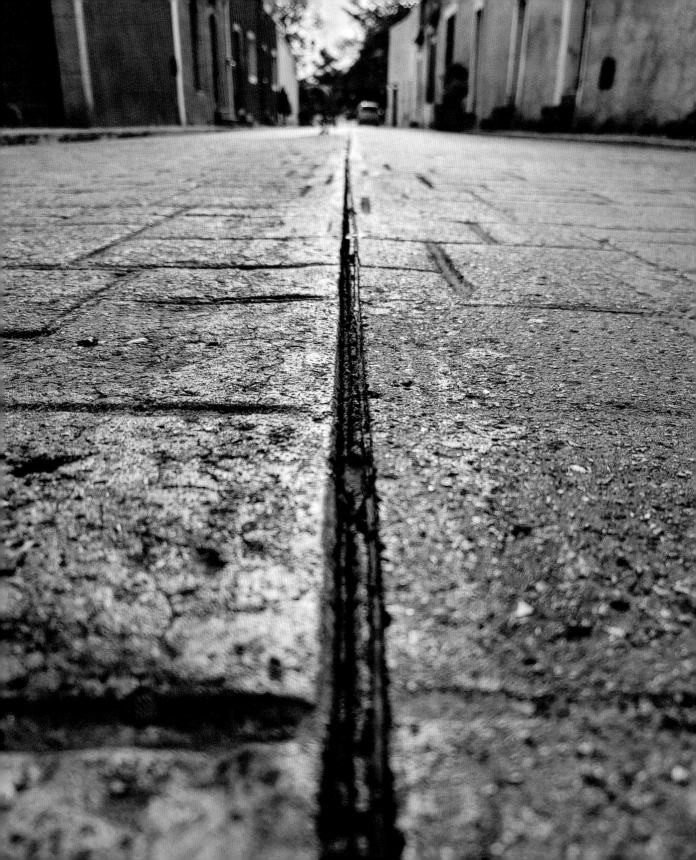

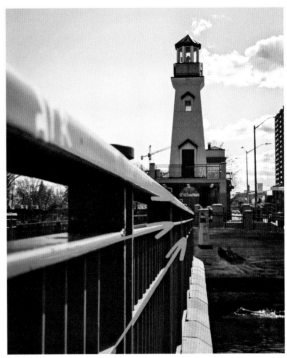

LEADING LINES TO LEAD THE VIEWERS' EYES

Leading lines are the lines in a photograph that you as a photographer can use to point toward your subject. It's as if you're drawing an imaginary map that leads to the most important part of your image.

Street lines are usually the easiest to see, but once you start looking, you'll realize that there are lines everywhere. You can use shadows, walls, rivers or anything else you can think of.

PHOTO CHALLENGE

Look around for leading lines, and take a picture using them. It can be a picture of a person or an object, as long as there are leading lines pointing toward them.

☀ PORTRAIT PHOTOGRAPHY

Make People Look Good in Every Shot

Scrolling through Facebook or Instagram, you've probably noticed that your screen is full of faces! Most of your friends like to take photos of themselves or other people. Whether it's a selfie, a group picture or a silhouette of someone in the distance, people like taking pictures of people. We ran a survey on our social media accounts asking people what they like taking pictures of and the answers confirmed our theory. Portraits came in at number one!

If portraits are that important, how do we make someone look good in a photograph?

Well, in addition to all the lighting and composition tools we've talked about, there are some techniques that work especially well when photographing people. Those include: angles, posing, cropping and more.

But before we talk about any of them, how can we make a person the most important part of the photo?

MAKE THEM POP

To make someone look good, the first step is to make them the highlight of the photo. You want all eyes to be on them! They need to stand out from the background and from the less important parts of the scene. There's a number of ways to achieve this.

Isolate Them with Focus

As we mentioned in the depth section (page 81), having your subject in focus while blurring the less important parts of the image makes it easier for your subject to stand out. You can have your subject move away from the background to exaggerate the effect.

With portraits, you have to make another choice: Which part of the person should you tap to focus on? The answer is the eyes—it's always the eyes (except when you can't see them). Try to make them your priority. Blurry eyes can ruin the best photo, so even if everything else is blurry, make sure the eyes are in focus.

PRO TIP: To take your portraits to the next level, try placing your subject in front of a window or an opening where the light is coming from. You'll end up with beautiful reflections in their eyes (called catchlights) and transform them into a Disney-like character.

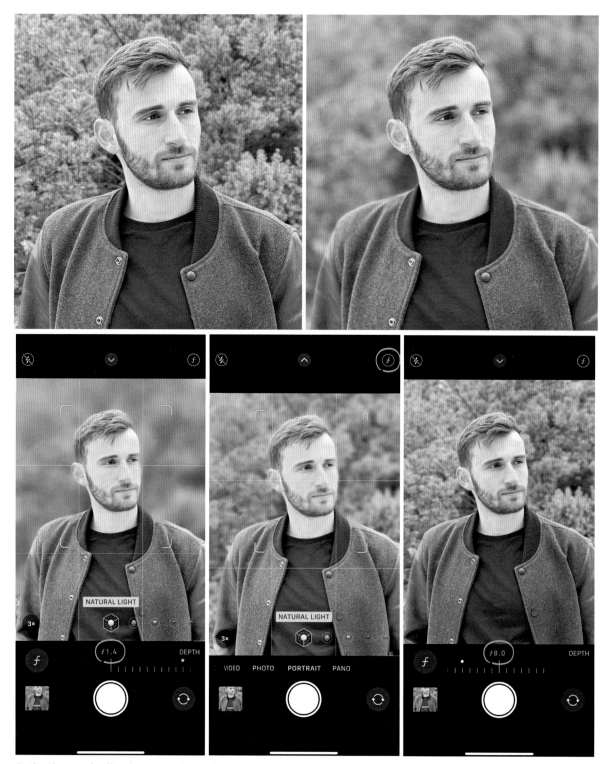

Activating and adjusting portrait mode

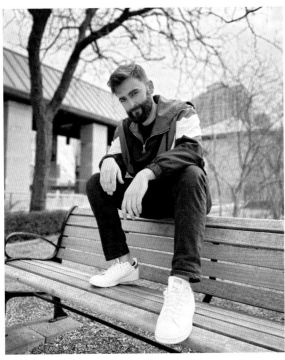

Using portrait mode results in a sharp subject and blurry background

Without portrait mode, the subject and background are both sharp

Portrait Mode

In your camera app, you'll see an option called portrait. When you're in portrait mode, your iPhone will artificially blur the background while keeping your subject in focus.

For this to work, you have to be relatively close to your subject. Don't worry, your iPhone will tell you to move closer if you're too far away.

You can also control how blurry and cinematic the background is by adjusting something called the *f*-number, which you can find at the right top corner of your camera app. The smaller the *f*-number, the blurrier the background. Experiment with different values and see what level of separation you like best.

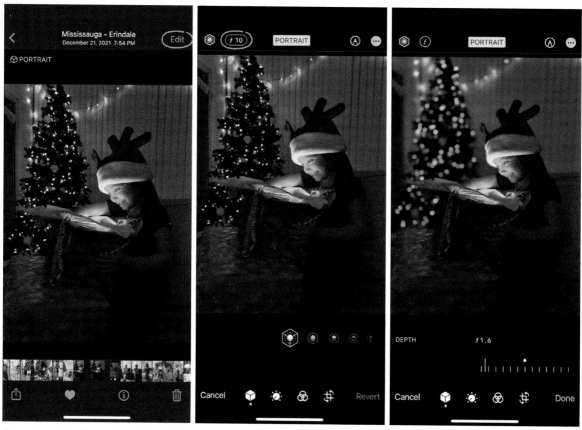

Changing the f-number after taking a shot

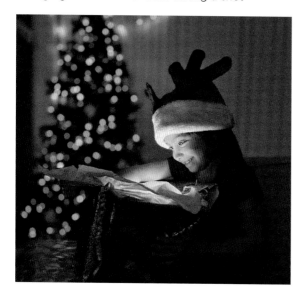

If you change your mind, you can adjust the f-number after taking the shot. To do that, open your photo, click on Edit, click on the f symbol and choose a new value.

FUN FACT: We placed a flashlight inside the gift box to light the girl's face. Notice how we've composed our shot using both depth and the rule of thirds.

PHOTO CHALLENGE

Take a picture of a friend using portrait mode. Open it in your gallery, change the *f*-number and notice how the background is affected.

Light on Dark and Dark on Light

Our eyes naturally go toward the brighter parts of a photo. An easy way to highlight someone in a photograph is to have them bright against a darker background or place them against the brightest part of the scene.

Every part of the subject matters. Think about their hair and skin color. If they are too similar to the background, the person will blend in and get lost in the photo. Notice how dark hair stands out against bright backgrounds and the opposite is true for light-colored hair.

The same logic applies when choosing the color of the outfit. If you know the area you're going to photograph in, pick an outfit that would contrast well against the background.

POSITIONING YOUR PHONE FOR FLATTERING IMAGES

Changing the position of your camera can dramatically change the feeling of the photo you get. It's a creative choice you can make depending on what you want to show in each shot.

Make it a habit to capture every scene from different angles, and you'll start noticing what angles you like best!

There are many different camera angles we can talk about, but we are going to focus on the main three: eye level, low angle and high angle.

PRO TIP: Showing the world from an angle people are not used to will produce more interesting photos.

Eye Level

If you hold the camera at your subject's eye level, your photo will mimic the way we see the world. It's a safe choice that helps the viewer connect to the subject of the photo.

Eye level becomes a creative option when it shows you the world of someone much smaller than you, like a child, an animal or even a flower. Bringing your camera down and taking photos at their level brings you into their world and shows you life from their perspective.

Low Angle

Another option is placing the camera below the subject's eye level pointing up at them. A low camera angle will make your subject appear bigger and more powerful as the viewer is looking up at them. The lower the camera, the bigger the effect. Use low-angle shots with your shorter friends and they will thank you!

PRO TIP: Have your model lean in toward the camera for flattering low-angle shots.

High Angle

Placing the camera above the person's eye level and pointing it down will make them look smaller. It's a great way to show where someone is and is perfect for travel photos. By placing them on the lower part of the frame, you can show more of the area and make the scene more important.

Take a look at the following examples. By photographing the same subject from three different angles, we're able to create three completely different shots of every scene.

High angle

Eye level

Low angle

High angle

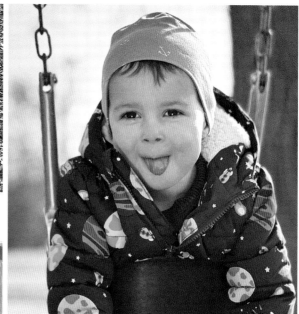

Eye level

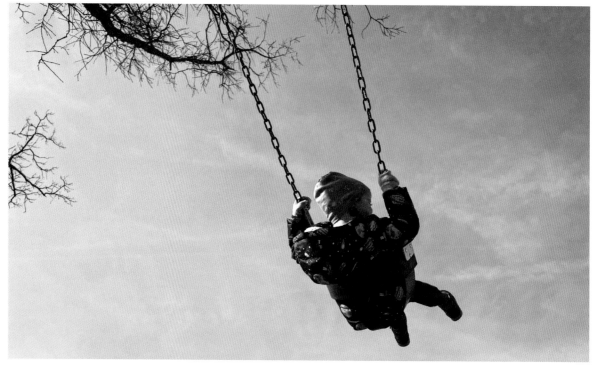

Low angle

Low angle

Eye level

High angle

PHOTO CHALLENGE

Create a set of three photos of the same subject from three different angles: eye level, low angle and high angle. The goal is to make each photo great in its own way.

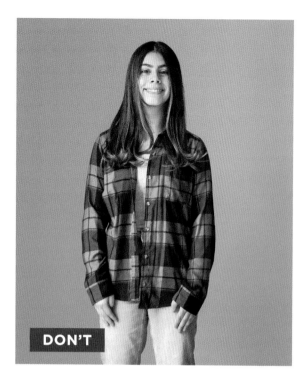

DON'T

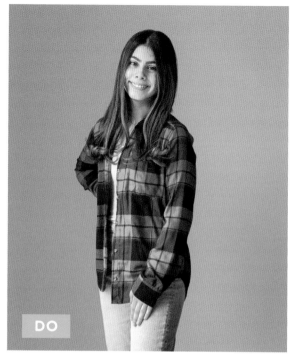

DO

POSING 101

As wedding photographers, the most common complaint we hear is a variation of "I feel awkward in front of the camera."

It's simple: People don't know how to stand and what to do with their hands. They can't see what they look like, so they end up feeling stressed. As a photographer, your job is to help them relax and make them look their best.

Adding Shape to the Body

When taking a picture, everyone's natural tendency is to stand directly facing the camera with their arms dangling straight by their sides. That usually looks boring and makes the person look boxy.

Instead, you want to have them standing at an angle to the camera with one foot closer to the lens. It adds interesting curves to their bodies and is usually more flattering. Experiment with different angles and see what you prefer.

DON'T

DO

Another tip is to have the model place their weight on one leg and relax the other. Give it a try! Stand in front of the mirror and notice what happens when you shift your weight between your feet.

The same logic applies when sitting or leaning against a wall. Straight lines are usually boring, so you want to find ways to introduce more shapes.

Use the Hands

Hands communicate a lot and can add interest to a photo. But, people don't know what to do with them, so they often leave them hanging at their sides. Others end up hiding them behind their back, but that doesn't look good either. You want to give yourself or the person you're photographing something to do.

It can be as simple as putting hands in pockets or on hips. You can also softly touch the face and the neck or play with hair. If you're wearing any accessories, you can hold or move them around for an interesting look.

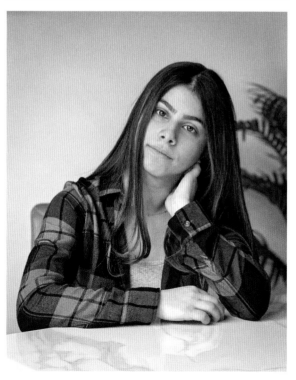

DON'T

DON'T

DO

Bring the Chin Down and Forward

Many people tend to lift their heads up when they're smiling in a photo. That creates a problem because the eyes end up looking partially closed. If you want bigger eyes in photos, lower your jaw a little bit and your eyes will automatically open wider while looking at the camera.

To avoid creating a double chin, push your chin a tiny bit forward (like a turtle). It might feel a little strange, but it works wonders to minimize your double chin and improve your jawline.

Make Them Move

Instead of telling someone exactly what to do with every part of their body, have them do something they've done a million times before and are comfortable doing. Try walking, jumping, spinning, throwing something in the air or anything else you can think of. The possibilities are endless. It helps people relax and gives you a mix of natural in-action shots. This works especially well when taking photos of children. They get excited by the activity and give you the most genuine expressions.

PRO TIP: If you end up getting blurry images, make sure your camera is steady and your scene has enough light.

Play with Props

A creative way to capture fun photos is to include activities, hobbies and props—anything that will make the model happy and make the photo more interesting. You can look directly at the lens or away from it for a more candid look.

PHOTO CHALLENGE

Go out with a family member or a friend and give them the best photo shoot of their life. Think of a game or a movement you can include to help them relax and look their best in front of the camera.

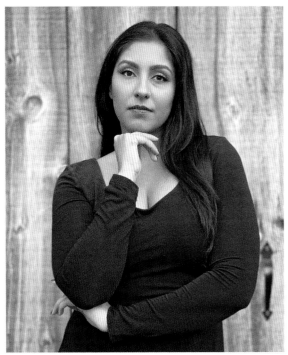

CROPPING YOUR PORTRAITS

Not every portrait has to be a full-body shot. Don't be afraid to get close! If you're taking a photo of someone (or cropping a shot you already took), you might find yourself wondering, "How much of the body should I include?" There are many good options and some common mistakes that are easy to avoid.

But first, let's get something out of the way. Getting physically closer to the model will always be better than cropping the photo after. Why? Because when you crop your photo after, you are sacrificing some of the quality. By moving closer, your photo will be sharper and will have more details.

Having said that, sometimes you might not have the time to get the perfect frame. Cropping your photo after gives you options and can take your shot from "okay" to "amazing."

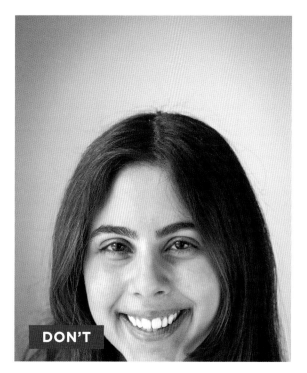

DON'T

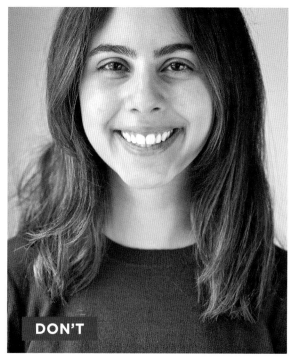

DON'T

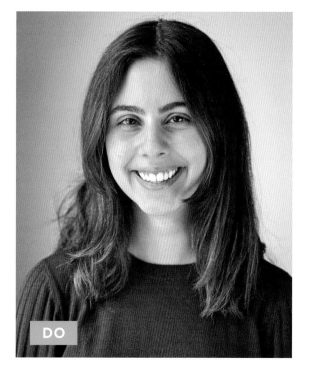

DO

Headshot Dos and Don'ts

Don't cut through the subject's chin. It makes them look like a floating head. Include the neck and shoulders.

Don't cut below the hairline. It makes the person look bald. It's okay to cut through the hair but not under it. Also think about the eyes. You usually want to position them in the top third of the photo.

Avoid Joints

One of the most common mistakes we see is photographers cutting off fingers and limbs. You never want to crop your photo at a joint (e.g., ankle, knee, elbow, knuckle, etc.). Cropping through a joint is very distracting and makes it look like there's a missing body part. Either include the full body part or crop away from the joint.

Notice how the photo on the right looks odd when the fingers are cropped. This could easily be fixed by taking a step back or pointing the camera lower.

DON'T

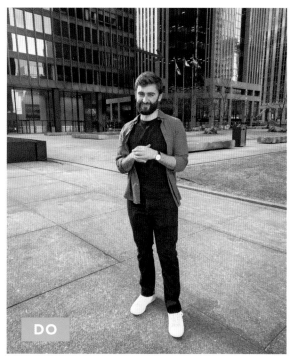

DO

HIDE DISTRACTIONS LIKE A PRO

The saying "less is more" has its own special place in photography.

A photo that includes too much is confusing. You look at it and you don't know its purpose or what you're supposed to be looking at. On the other hand, a simple photo that has a clear point of interest is pleasing to the eye.

Here are some useful tips to simplify your scene.

Remove What You Can

Pay attention to your scene and make it a habit to ask yourself, "Is there anything unnecessary in my photo? What can I remove to improve this shot?"

Sometimes, all it takes to improve your photo is removing an object or slightly adjusting your angle. In this example, we removed the orange cones.

Notice how by slightly changing the angle of the photo, we were able to avoid having the flag sticking out of Yasseen's head.

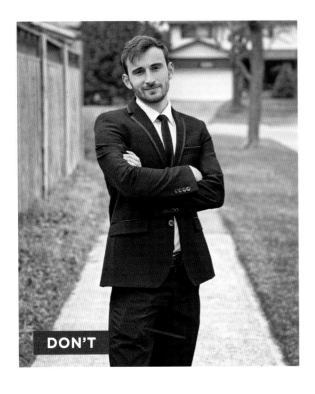

DON'T

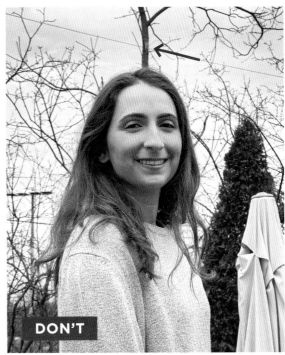

DON'T

Here are some common distractions to look out for:

An obvious phone in the pocket stretches the fabric and doesn't look good. Give it to someone or leave it outside the shot until you're done.

Avoid tree branches and poles coming out of heads. It's very distracting and can easily be avoided by adjusting your angle.

Pay attention to any random objects that might distract from your subject and remove them if you can (especially if they're bright in color).

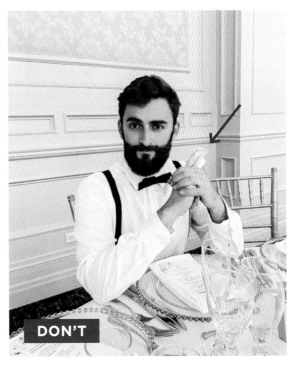

DON'T

This eye-level shot shows many distractions

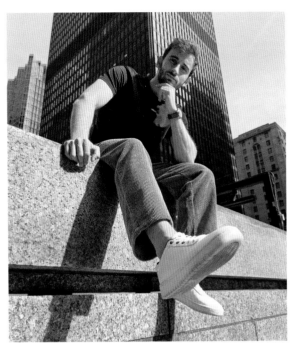

This low-angle shot hides distractions

Find a Simpler Background

If you find yourself somewhere where the background is just way too busy, you might be better off finding a simpler one.

Look around and find an angle that has less clutter. Use it to frame your subject and snap away.

Another interesting option is to change the perspective of your shot with low and high angles. By pointing up or down, you might be able to avoid the parts of the image you don't want to show, and you'll create a simple background for your subject to stand out against.

PRO TIP: If the scene is not important, you can always use portrait mode to hide distractions and simplify your photo.

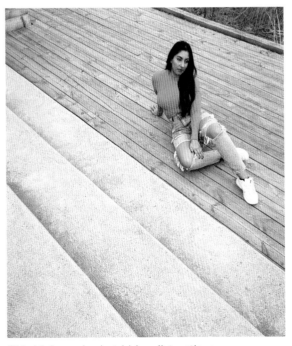

This high-angle shot hides distractions

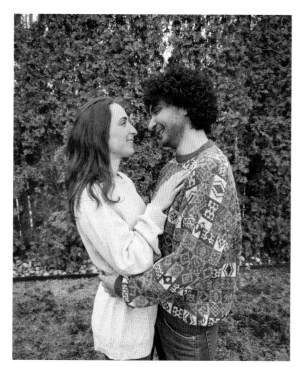

Adding the flowers hides the messy ground and introduces color to the photo

Covering a Part of the Scene

Sometimes you can improve a scene by using an object to cover the parts you want to hide. You can use an element from the scene (like the wall in the photo on the next page) or bring in your own (like the flowers above). You get bonus points if the element adds texture or color to your photo.

PHOTO CHALLENGE

Grab a friend and go to a busy street where there's a lot going on. Find different ways to simplify your scene and capture three beautiful portraits highlighting your model with minimal distractions.

☀ THE SELFIE

There's More to It than You Think

A selfie is a photo you take of yourself typically using the front-facing camera. While selfies are very similar to other kinds of portraits, there are some tips that'll specifically improve your selfie game and make you look so much better. This chapter will be a combination of the lessons we covered in previous chapters and how they apply to selfies.

Use a hat to create your own shade and avoid the harsh sun

Place the sun behind you to provide even lighting for selfies

THE RECIPE FOR A KILLER SELFIE

It may seem hard to make a selfie look good. However, there are a number of tips and tricks you can use to get an impressive shot even when you're photographing yourself.

Light Matters

A great selfie is sharp and well-lit.

Phone cameras struggle in low-light situations, and they produce photos that are grainy and full of noise. While this can easily be seen in nighttime selfies, you might run into the same problem during the day depending on the direction of the light and how you're standing.

To improve the sharpness and the quality of your selfie, the number one rule is to make sure there's enough light shining on your face.

It's good to build the habit of rotating and moving your phone around to see how the light and shadows change on your face.

When the light is soft (e.g., on a cloudy day or window light), you typically want to face the light source to minimize the shadows under your eyes and to hide skin imperfections. If you're indoors, stand facing a window or a lamp, or look up toward the ceiling lights.

If you're out in the sun, try backlighting or any of the techniques we mentioned in the "High Sun" section (page 47).

Not enough light on the face results in a grainy selfie

More light shining on the face results in sharper selfies

If you're somewhere dark, try to get close to any source of light you can find. Notice the difference in quality when you do.

Be Perfectly Still

You'll often find yourself taking your selfie with one hand and your arm extended all the way to fit more into your shot. The problem is, when you click to take the picture, your phone might shake a little and the photo might be somewhat blurry. Holding the phone with both hands is not always convenient, and your arms might end up blocking too much of the scene.

To get the sharpest selfie possible, a useful trick is to set a three-second timer, click the shutter and freeze for the shot. You'll feel the difference, especially in difficult lighting conditions and at night. Another good option is to lean against a wall or rest your phone-holding hand on a solid object. Basically, you want to do everything you can to make sure both you and your phone are as stable as possible when taking the shot.

Looking at the screen looks awkward in selfies

Looking at the camera results in better selfies

Look at the Camera

One very common mistake when taking a selfie is looking at the phone screen instead of the lens. We're all guilty of this! It's so hard to ignore the face looking back at you, and you want to see what you look like. You end up with a strange-looking selfie with your eyes partially closed and you looking down or off to the side.

To fix that, take your time looking at the screen and once you've figured out the perfect angle, hold still, look directly at your lens and snap away.

Selfie before facing the window with no catchlight *Selfie facing the window with catchlights*

Add a Catchlight

The first thing that grabs attention in a portrait is the eyes. To take your selfies to the next level, try facing an opening where the light is coming through. The shape of the opening will be reflected in your eyes, creating beautiful bright spots (called catchlights) that make your image more captivating. Try this in front of a bright window, a door or an opening between the trees. Experiment with different shapes and positions to find what you like best.

PHOTO CHALLENGE

Make your eyes shine in a selfie. Find a bright opening and use it to create catchlights in your eyes. Move toward or away from the opening and notice how the catchlight's shape and size change.

Eye-level selfie

High angle selfie

Side selfie

Experiment with Angles

Instead of taking your selfie straight on with your face square with the camera, try different angles. Raise your phone, lower it or move it to one side. You can also tilt your head or lower one shoulder to add interest to your selfie.

Everyone's face is different, and experimenting will help you find your best angle. No matter what angle you choose, you still want a sharp, high-quality photo, so make sure your face is well-lit and try to be as steady as possible.

The advantage of raising your phone is that your eyes end up opening wide as you look up at your camera. It's a flattering look that often improves the lighting on your face, since most light sources are above eye level (e.g., the sun, ceiling lights, etc.). It also hides your double chin and makes your face appear slimmer.

Low-angle selfie

Low-angle selfie

If you're taking a selfie from a low angle, try leaning your body toward the phone and lower your chin a tiny bit to allow your eyes to open. If you notice a double chin, try extending your neck a tiny bit forward toward the lens. Ideally, you want the ground to be a bright color that can reflect some light back onto your face.

Shooting up or down can give you unique selfies because it shows an interesting angle people are not used to seeing and helps you simplify the background.

PRO TIP: The lighting on your face is influenced by the color of your surroundings. For example, if you're standing in a grassy area, your face will have a green tint from the light reflecting off the ground.

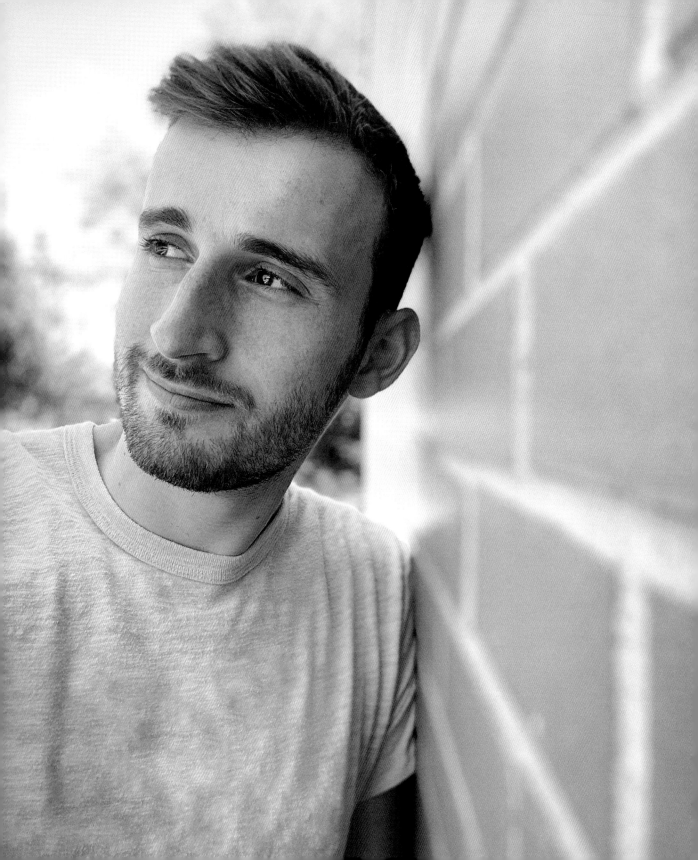

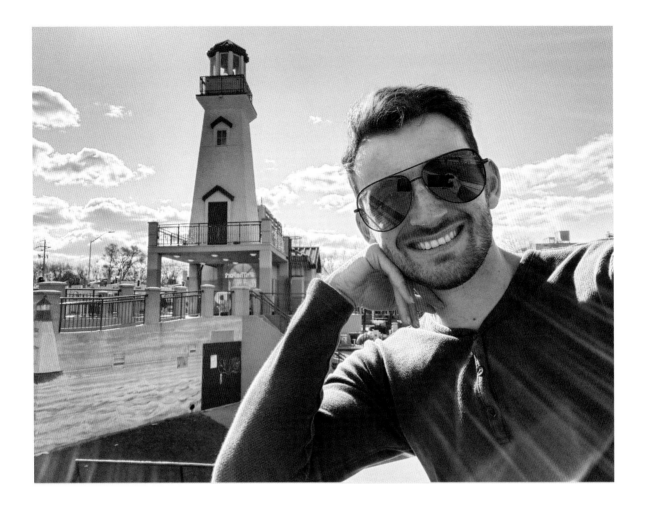

Background Choice

The background is still important in a selfie. It can ruin your shot or it can make it better. You can use compositional tools such as leading lines (page 99) or the rule of thirds (page 87) to highlight your face and create more powerful images.

Selfies are all about showing your face. Look for anything that can be distracting and try to avoid it by physically removing it or by adjusting your angle.

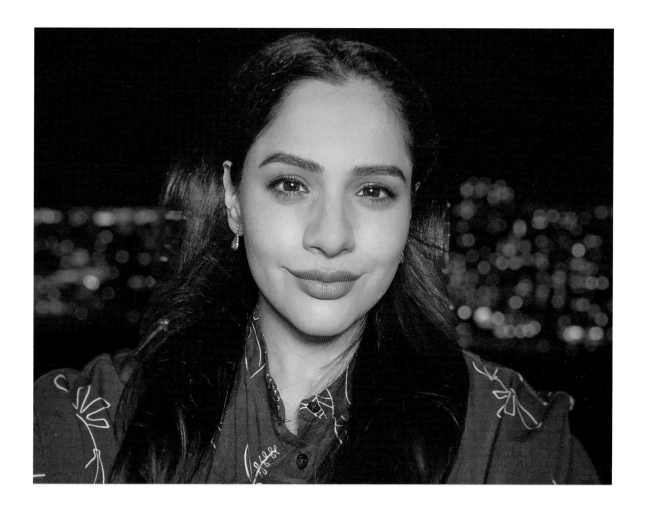

Try Portrait Mode

As we mentioned on page 105, portrait mode blurs the background while keeping the subject nice and sharp. The same benefits can be used when taking a selfie. Portrait mode will help you stand out and will give your selfies a sense of depth by separating you from your background. Choose the level of separation by changing the f-number before or after you take the shot.

PRO TIP: Portrait mode can turn small light spots into beautiful blurry balls of light. Try it with fairy lights and street-lights for a magical background.

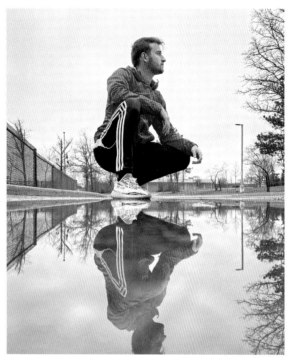

MAKE IT MORE THAN A "SELFIE"

While a traditional selfie has a familiar friendly feeling everyone knows and loves, it can be a little limiting. You can only show so much while holding your phone, and compared to the main iPhone cameras, the front-facing camera is always smaller and less capable.

Use the Main Cameras

Most people use the front camera to take their selfies; however, the back ones offer many advantages. Back cameras have bigger sensors that are much more advanced, which means your photos will be sharper and of higher quality.

Of course, it will be a little harder to frame the shot since you can't see yourself, but the quality difference will be worth it.

Put Your Phone Down

By using a tripod or leaning your phone against a stationary object, you're no longer limited to being (literally) an arm's length away from your camera. It frees your hands and allows you to do and show more in your selfie. Once you find an angle you like, set a three- to ten-second timer and get in position.

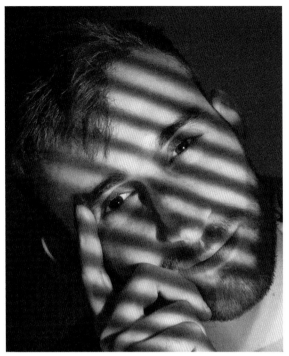

FUN IDEAS YOU CAN TRY TODAY

Get Dramatic

Use the techniques you learned in the dramatic lighting section (page 61). Find a dark spot and use sunrays or a flashlight to create a dramatic side-lighting look. You can also use household items to modify the shape of the light and create interesting shadows.

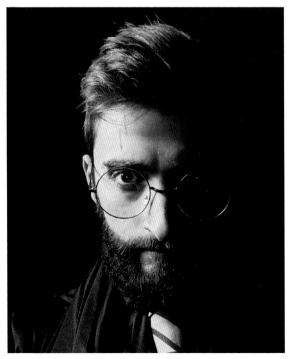

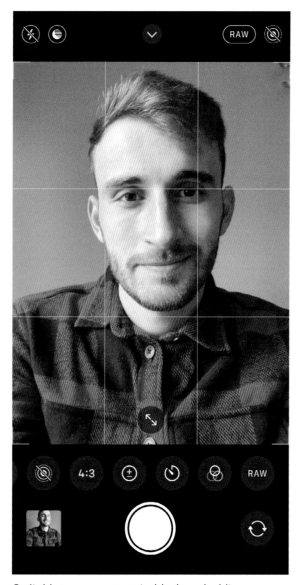

Switching your camera to black and white

A Selfie within a Selfie

For this one, you're going to need a second phone. Place the second phone on a tripod, start a 3- or 10-second timer and get into position. Including your phone screen in the shot adds a frame within your frame and gives a unique look.

To switch your iPhone camera to black and white, go to your camera app, swipe up to reveal additional options, click on the icon with the three intersecting circles, swipe all the way to the end and choose Noir.

Add Movement

By adding some sort of movement, you can create fun dynamic shots that will catch people's attention. You can throw something in the air, flip your hair or play with a flowy outfit. Using a tripod and your camera timer will give you more freedom and ensure that your camera is rock-steady.

PRO TIP: Moving objects can become blurry in a photo. To photograph fast movement, you have to be somewhere bright to allow your phone to capture quick, sharp shots.

Another fun way to add a sense of movement to your photos is by using live mode. Any live photo can be turned into something called "long exposure." In a long exposure, your iPhone will combine the frames of a live photo into one still shot. Anything that moves during the live photo will become blurry, while stationary objects will remain sharp.

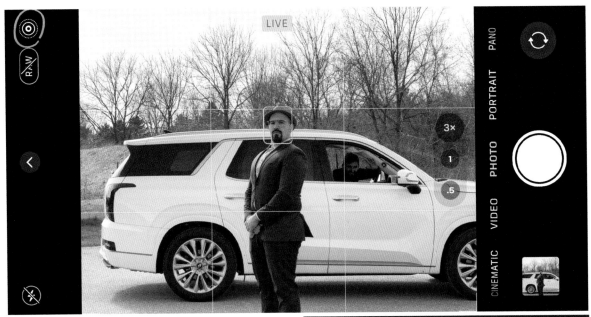

To try it, make sure live mode is turned on, snap a photo where something is moving (the white car in our example), open it in the gallery app, click Live at the top left corner of your screen and select Long Exposure.

PRO TIP: What makes long exposures interesting is having both sharp and blurry parts. The natural shaking of your hand might make the entire scene blurry and can ruin a long exposure. For the best long exposure shots, put your phone on a tripod and use your camera timer to take the shot.

☀ YOUR IPHONE PHOTOGRAPHY CHEAT SHEET

This is a summary of the most important tips mentioned in this book. It'll be a useful resource if you want a quick reminder of what you've learned. We've organized this section based on the most common situation you might find yourself in. For each one, you'll find a list of suggestions that'll make your life easier and help you capture beautiful shots, as well as page number references in case you want to give yourself a full refresher.

GENERAL TIPS

1. Turn on your camera grid. It'll help you center your shots and place the elements you see on your screen (page 16).

2. Don't let your phone guess where to focus. Tap on your screen to choose the focus yourself (page 20).

3. Don't let your phone choose the brightness of the photo. Tap your screen and slide the sun icon up or down to adjust it to your liking (page 24).

4. Watch out for and try to avoid distractions that take away from the scene you're trying to capture (page 126).

IS YOUR PHOTO BLURRY?

1. Clean your lens (page 23)!

2. Try to be as stable as you can. Hold your phone with two hands and tuck your elbows in or lean against a stable object (page 136).

3. Don't zoom in digitally unless you have to. Zoom with your feet by moving closer to the scene (page 22).

4. Make sure your scene has enough light. Figure out where the light is coming from and use it to your advantage (page 32).

DO YOU WANT TO MAKE A PHOTO MORE INTERESTING?

1. Add a sense of depth by including foreground elements or a distant background (page 83).

2. Using the rule of thirds, try placing your main subject at an intersection of the grid lines for a unique composition. Try the different intersection points and see which one gives you the most pleasing image (page 87).

3. Look for leading lines that can add a sense of direction to your photo (page 99).

4. Find natural frames you can shoot through or place around your subject (page 95).

5. Add elements of symmetry. Experiment with water and glass reflections or find a symmetrical scene (page 90).

IF YOU'RE TAKING A PICTURE OF SOMEONE

Are you taking it indoors (page 35)?

1. Turn off the lights and get them close to a window for some natural light (page 32).

2. Turn off ceiling lights and find a lower light source closer to the person's eye level (e.g., a candle, a lamp, etc.).

Are you outside and the sun is too harsh (page 47)?

1. Place the sun behind the person to eliminate shadows under their eyes and give them a golden outline.

2. Take them in the shade to have soft, even light on their face.

3. Have them wear a hat or sunglasses to get rid of the shadows under their eyes.

4. Use the direct sun to add interesting shadows for a more dramatic look.

Shooting during golden hour (page 45)?

1. Use the orange glow of the sun to cast a warm light on the person's face.

2. Silhouette your subject against the colorful clouds for a unique shot.

Are you somewhere dark (page 32)?

1. Find a light source and have them get close to it.

2. Bring your own light and use it to light their face.

3. If there are no other options, use your phone camera's flash.

Do you want a more dramatic shot (page 61)?

1. Go somewhere dark and use side lighting to add contrast and exaggerate the shadows.

2. Use a strong source of light and an everyday item (e.g., a leaf, a comb or a strainer) to create interesting shadows on the person's face.

Is the background too busy or cluttered (page 126)?

1. Remove what you can.

2. Find a different background.

3. Change your camera angle. Place your camera low and shoot up or place it high and shoot down for a simpler background and a unique perspective.

4. Use portrait mode to blur the background and highlight your subject.

Do you want to make them look taller and more powerful (page 111)?

1. Lower your phone below the person's eye level to elongate their legs and make them appear taller. The lower you go, the taller they'll appear.

You want to get rid of the double chin (page 120)?

1. Have the person lower their chin a tiny bit and extend it forward toward the lens.

2. Shoot from a higher angle to hide the double chin and make the face appear slimmer.

Does the person look or feel awkward in the photo (page 121)?

1. Add shape to their body by having them sit down or lean against something.

2. Have them move to help them relax: walk, jump, dance or throw something in the air.

3. Ask them to do something with their hands: put them in their pockets, place them on their hips, touch an item of clothing, etc.

IF YOU'RE TAKING A SELFIE

1. Set a three-second timer to avoid shaking your phone every time you take the shot (page 136).

2. Don't look at the screen while taking the shot. Instead, look directly into your lens (page 137).

3. Make sure there's enough light shining on your face (page 134).

4. Experiment with different angles to find your favorite shot (page 140).

5. Try using the back cameras to capture high-resolution selfies (page 145).

6. Place your phone on a tripod or lean it against a stationary object, then use your camera timer to free your hands and have more freedom in your shots.

☀ PHOTO CHALLENGES

Finding inspiration can be difficult at the beginning of your photography journey. To get you started, we've put together a list of photo challenges that summarize many of the lessons you've learned in this book.

Each challenge is designed to show you the capabilities of your phone or to help you build a new skill. By the end of these challenges, you'll feel more confident in your photography skills, and you'll find it easier to come up with your own creative ideas. You can always refer back to the relevant section of the book for helpful tips and photo examples to re-create. Have fun!

1. Take two pictures of a faraway subject. Try taking the exact same shot once by zooming in digitally and another by walking closer to the subject. Notice the difference in quality (page 22).

2. If you have multiple lenses on your iPhone, pick a subject and take a picture of it using each lens. Try to keep your subject the same size in the frame by moving closer to or farther away from it. Notice the difference between the shots (page 28).

3. Go out and capture a front-lit portrait. Make sure the light is soft by going on a cloudy day or during golden hour. Move your model around and position them in a way that gets rid of any shadows on their face (page 36).

4. Go out with a friend on a sunny day and take a backlit photo of them. Try placing the harsh sun on their face and then walk around and place it behind them. Notice the difference (page 41).

5. Find a lamp with a removable shade and place it in a way that only lights one side of your face. Take a selfie with the shade on (soft light) and then without it (hard light). Notice how the shadows change (page 42).

6. Plan a photo shoot during golden hour where you capture a front-lit golden portrait and a creative silhouette (page 46).

7. On a sunny day, capture a creative picture using a common everyday item (e.g., a leaf, or a fence) to create interesting shadows (page 51).

8. Go out and capture the city lights at night. Remember to let night be night and be in control of your camera's brightness (page 58).

9. People often look for soft, even light when taking their photos, but hard light brings its own magic. Create a dramatic portrait where the light is shining only on your model while everything else is in pure darkness. Find a light source, get close to it and lower your camera's brightness for a dramatic look (page 69).

10. Capture three scenes that are better photographed in the landscape orientation and another three that would look better as portraits (page 78).

11. Find a scene where you can create depth by including something in the foreground. Take the shot with and without the foreground element and notice the difference (page 84).

12. Find a landmark or an interesting structure near you and take a picture of it using the rule of thirds. Try placing it on different intersections and choose your favorite one (page 89).

13. Take a perfectly symmetrical photo. You can look for symmetry around you, or you can create it yourself (page 92).

14. Go out with a friend and take a picture of them using a natural frame in your environment. You can use trees, buildings, doorways or even the clouds. Get creative (page 96)!

15. Look around for leading lines, and take a picture using them. It can be a picture of a person or an object, as long as there are leading lines pointing toward them (page 99).

16. Take a picture of a friend using portrait mode. Open it in your gallery, change the *f*-number and notice how the background is affected (page 107).

17. Create a set of three photos of the same subject from three different angles: eye level, low angle and high angle. The goal is to make each photo great in its own way (page 115).

18. Go out with a family member or a friend and give them the best photo shoot of their life. Think of a game or a movement you can include to help them relax and look their best in front of the camera (page 122).

19. Grab a friend and go to a busy street where there's a lot going on. Find different ways to simplify your scene and capture three beautiful portraits highlighting your model with minimal distractions (page 130).

20. Make your eyes shine in a selfie. Find a bright opening and use it to create catchlights in your eyes. Move toward or away from the opening and notice how the catchlight shape and size changes (page 138).

ABOUT THE AUTHORS

Yasseen and Moaz Tasabehji are the founders of CameraBro, one of the fastest-growing online photography education platforms. After spending many years as wedding photographers, the brothers started sharing their knowledge through short video tutorials that allowed their followers to get into photography without the need for fancy equipment or technical knowledge. Now full-time educators, Yasseen and Moaz call the Toronto area home. You can visit them online at www.camerabro.com or @camera_bro_ on Instagram.

✺ ACKNOWLEDGMENTS

Writing a book is harder than we thought and more rewarding than we could've ever imagined.

To our amazing online fans, thank you. You might not know it, but you were a part of the momentum that carried us to the top and allowed us to be a part of wonderful projects, including this book. Thank you for liking our content and sharing it with your friends. You are the reason we're able to make a career out of our passion.

Social media has a bad reputation, sometimes rightfully so, but we'll be forever grateful for the platforms—TikTok and Instagram—that allowed us to share our knowledge and create value for millions of people around the world.

Our time in the wedding industry was worth it. We learned so much and we developed as photographers. To all our amazing couples, thank you for trusting us and allowing us to be a part of your special celebrations.

To Fatima, who created our first social media account and showed us that it's possible to succeed online, we owe you way too much and we will be forever grateful.

To Zahira, who gave us her time generously and modeled for our tutorials without ever complaining. You are the sweetest human and we're so lucky to have you.

To Khaled, who was always the first one to like our posts and let us know what's trending in the TikTok world. You are wise beyond your years and we love the young man you've become.

To Nour, who let us use her home and turn it into a chaotic workspace 24/7. Thank you for your patience and for all the chickpea salads.

To Simmy, who was so excited about this book that she got us excited to write it. Thank you for being proud of us and for encouraging us to do our absolute best.

To Andres, who was always ready to offer his time and provide feedback. Thank you for helping us develop our ideas and fine-tune the results.

To everyone at Page Street who believed in us, thank you for allowing us to create a legacy and turn our ideas into a beautiful manuscript.

INDEX